SNOG

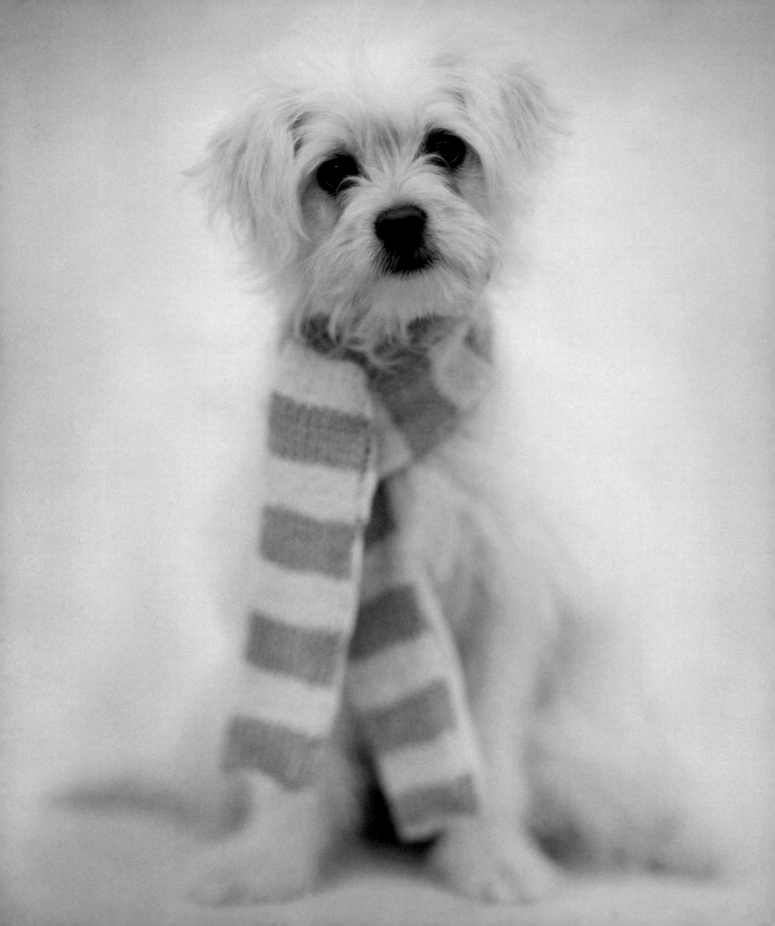

SNOG

A Puppy's Guide to Love

RACHAEL HALE

Little, Brown and Company
New York Boston London

Who better than a puppy to give us guidance on the nature and beauty of love?

When I met my dog Henry, it was love at first sight. He was a young puppy, just old enough to be picked up from the breeder.

This gorgeous, round bundle of fur was deposited in the car, on the floor of the passenger seat next to me, set for our journey home. Within minutes, Henry had clambered onto the seat and was staring at me with his huge, adoring eyes.

As we drove over a noisy bridge, Henry – terrified – clambered across onto my lap and snuggled against me seeking refuge. The bond was instant, and the love entirely mutual.

From that moment on, Henry and I were inseparable. My friends, invited over to meet "the new man in my life," were slightly surprised when introduced to a one-foot-high, fluffy canine but they, too, were soon under Henry's spell.

The puppies of all shapes and sizes that feature in the following pages are each unique. They are lovable for sometimes very different reasons, but the love they have to give is consistent and unconditional. Who better than a puppy to give us guidance on the nature and beauty of love?

RACHAEL HALE

Love is…

the triumph of imagination over intelligence.

H. L. MENCKEN

ROKO LABRADOR RETRIEVER ▶

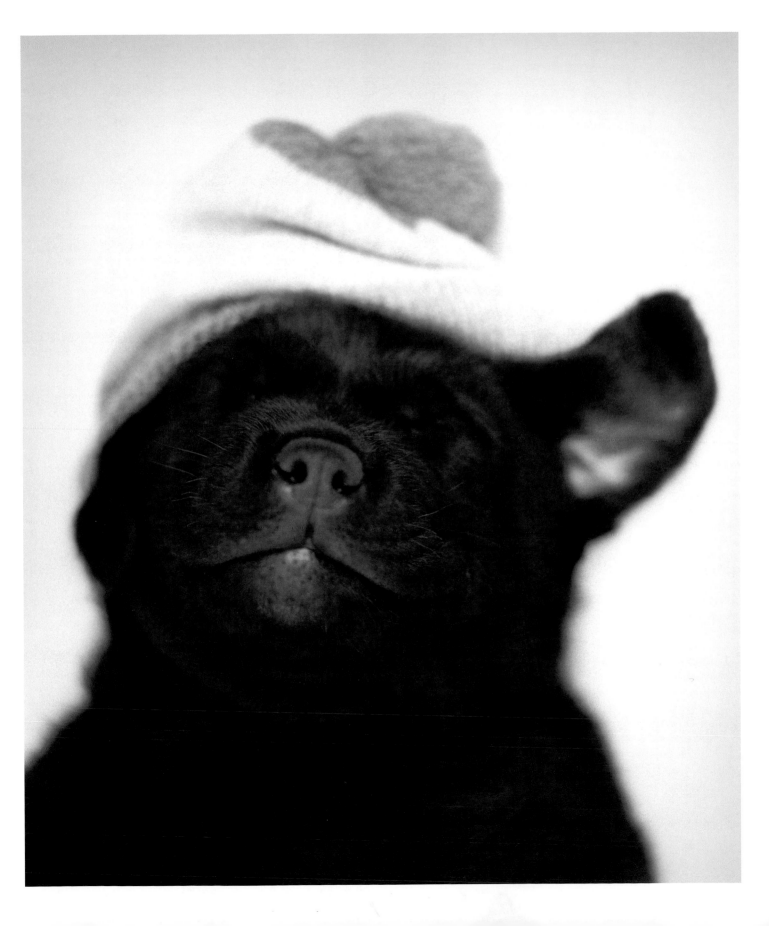

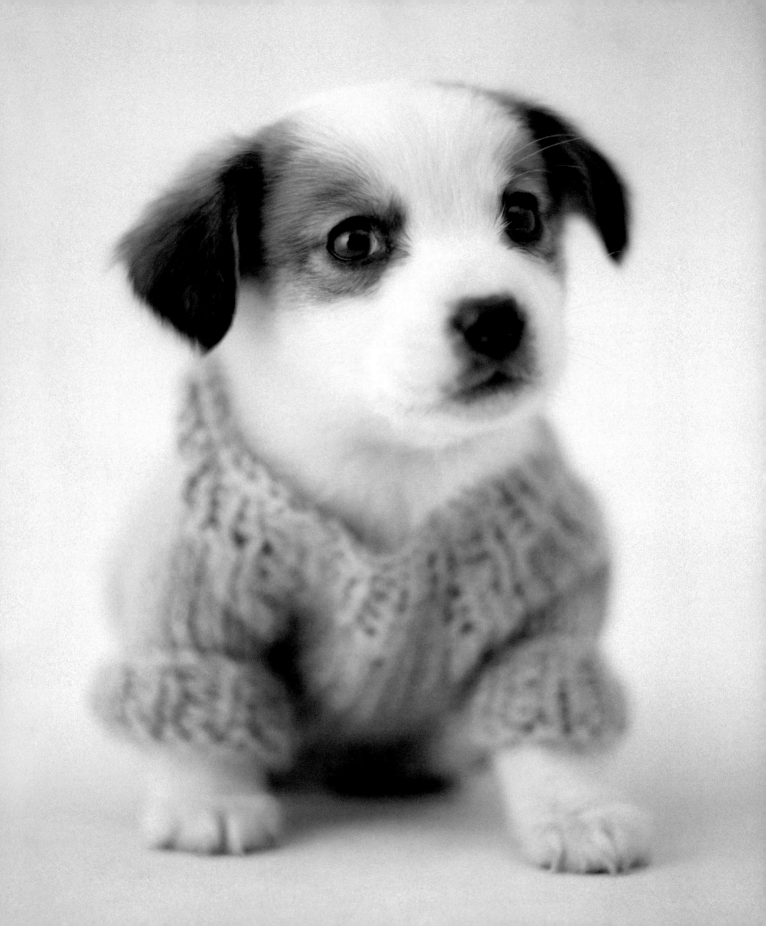

And love is...

wearing matching sweaters.

KIRBY PARSON RUSSELL TERRIER CROSS ▶

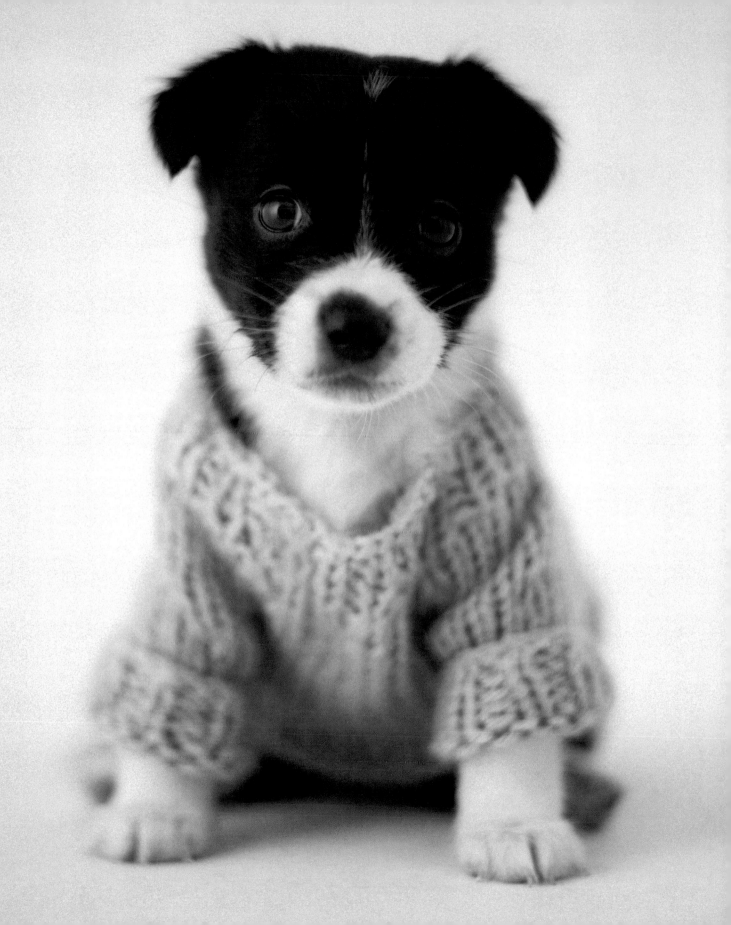

All I ever really need is love...

CHLOE LABRADOR RETRIEVER ▶

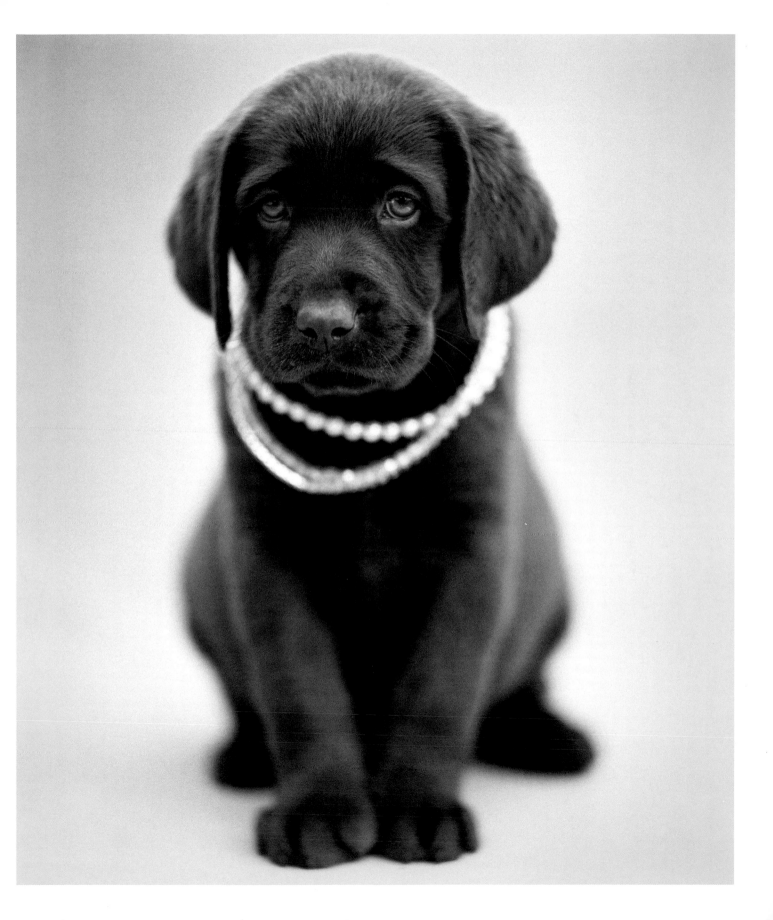

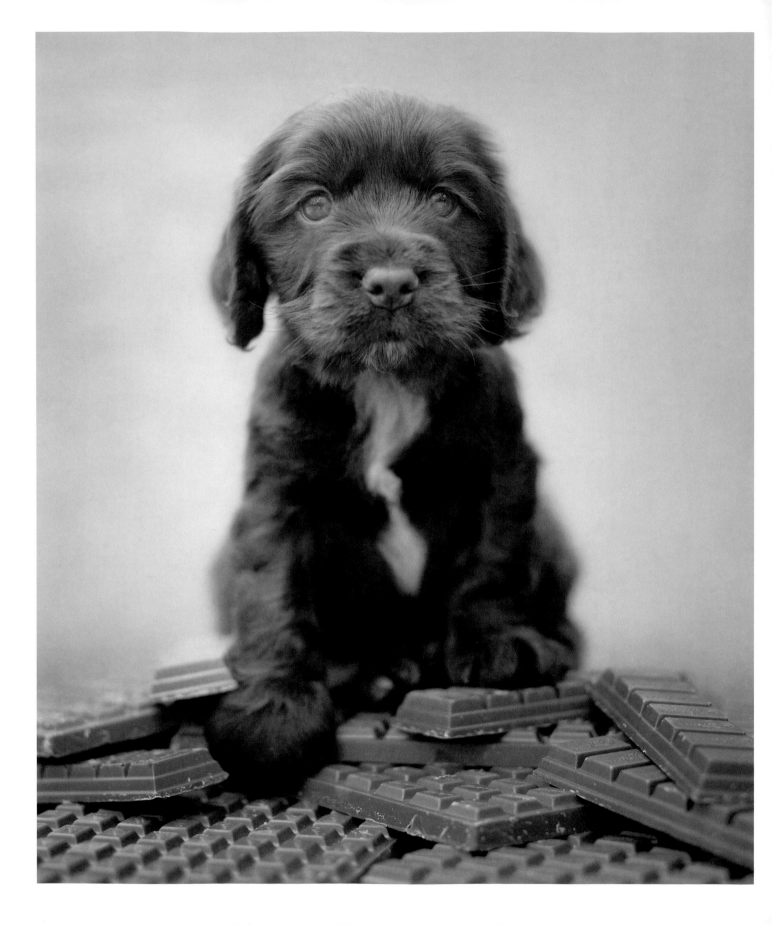

but a little chocolate now and then doesn't hurt!

LUCY VAN PELT

◄ SEBASTIAN ENGLISH COCKER SPANIEL

ZOEY BOXER

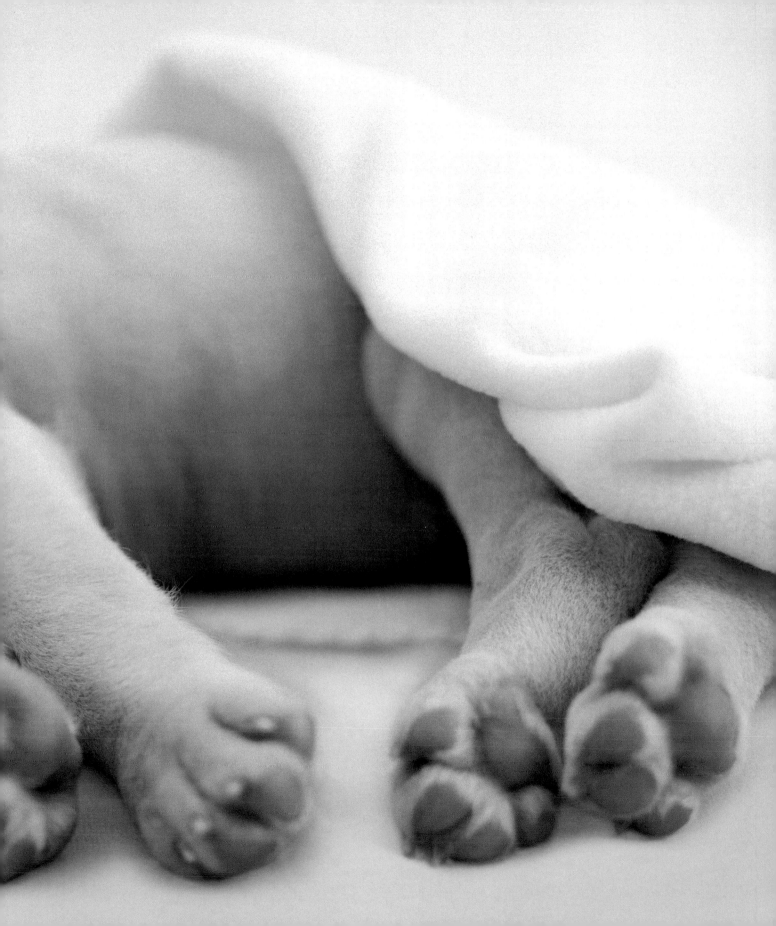

I think we dream so we don't have to be apart so long…

BRUISER BASSET HOUND ▶

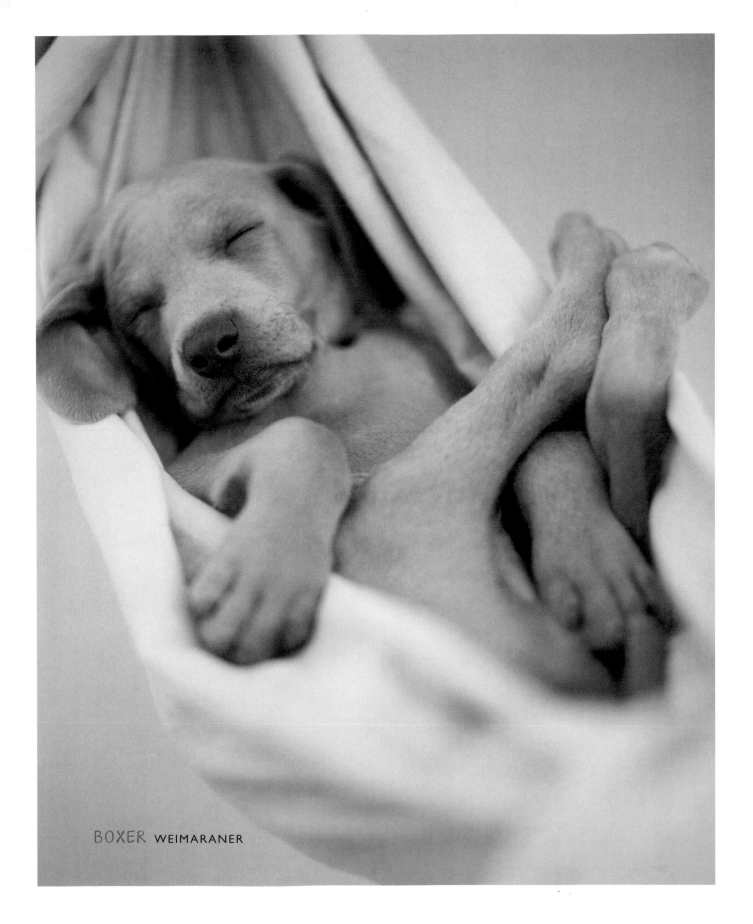

BOXER WEIMARANER

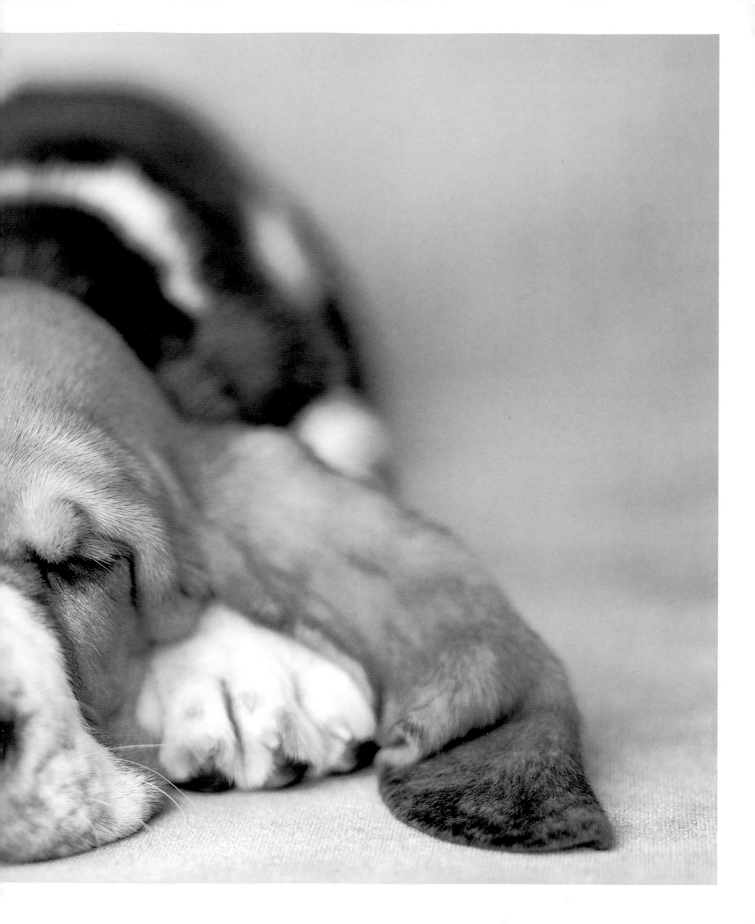

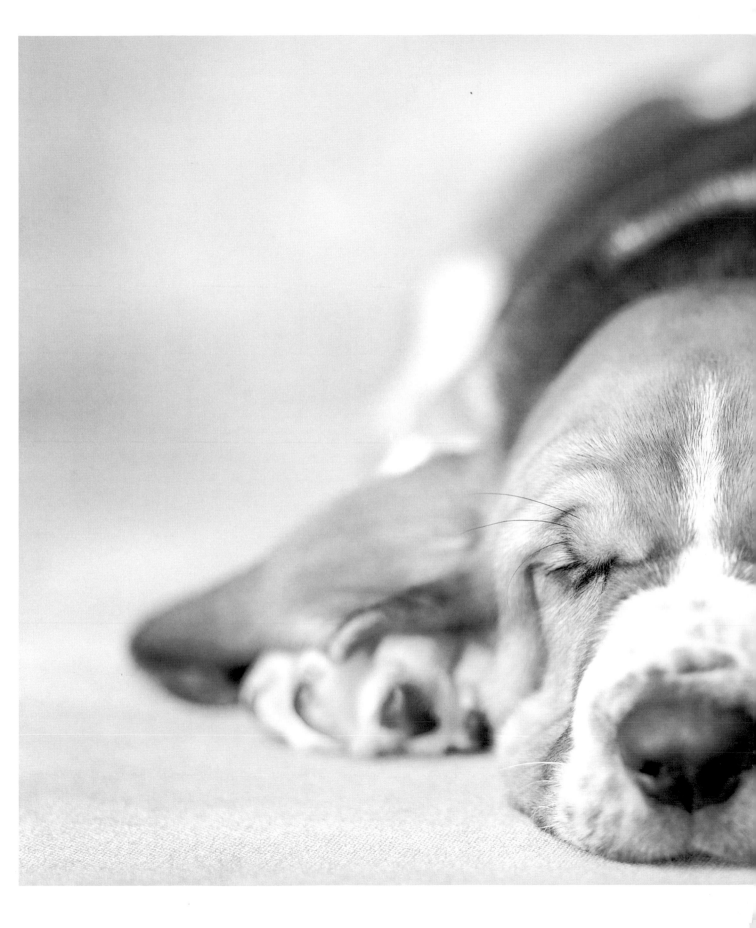

If we're in each other's dreams...

RUSTY BLOODHOUND ▶

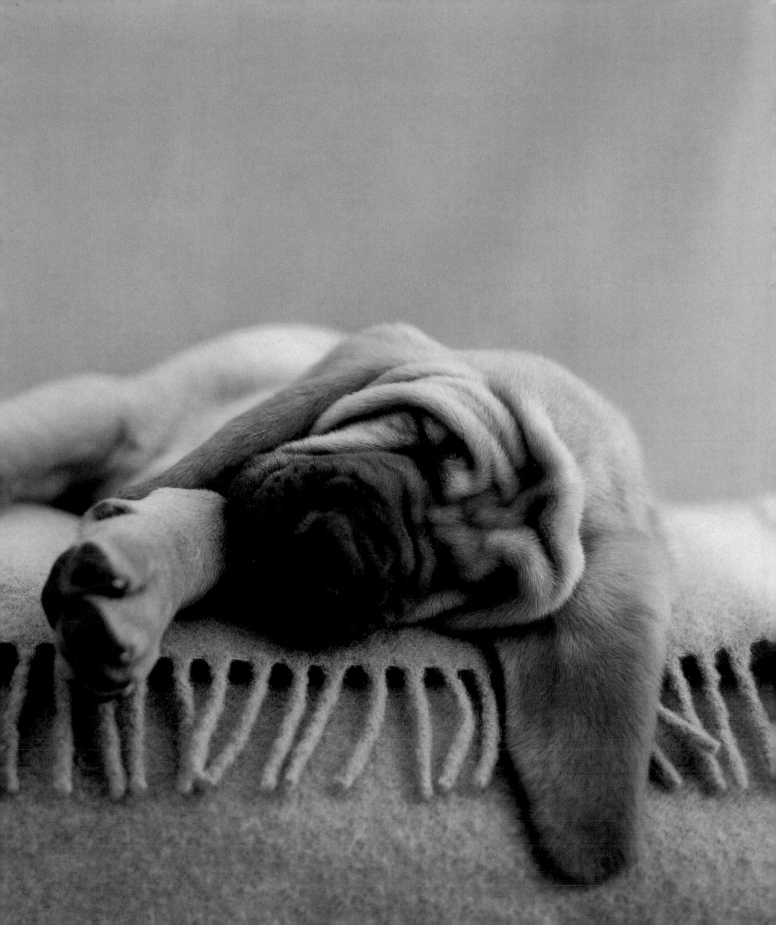

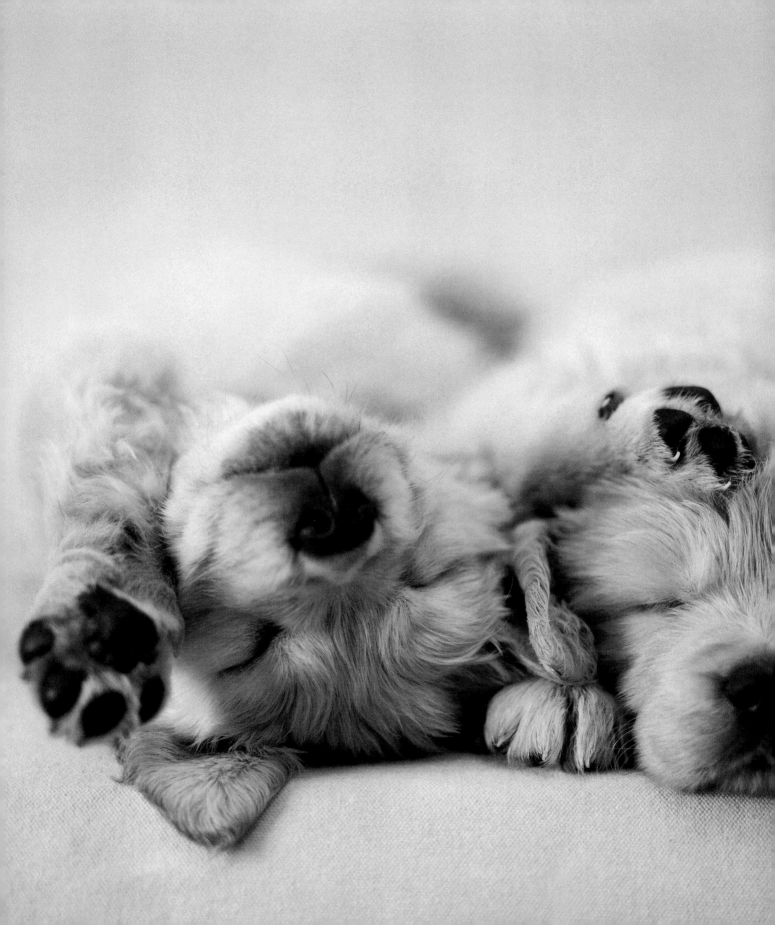

we can be together all the time.

BILL WATTERSON

◀ JAY & CONNIE **GOLDEN RETRIEVER** 27

SOPHIE ENGLISH COCKER SPANIEL ▶

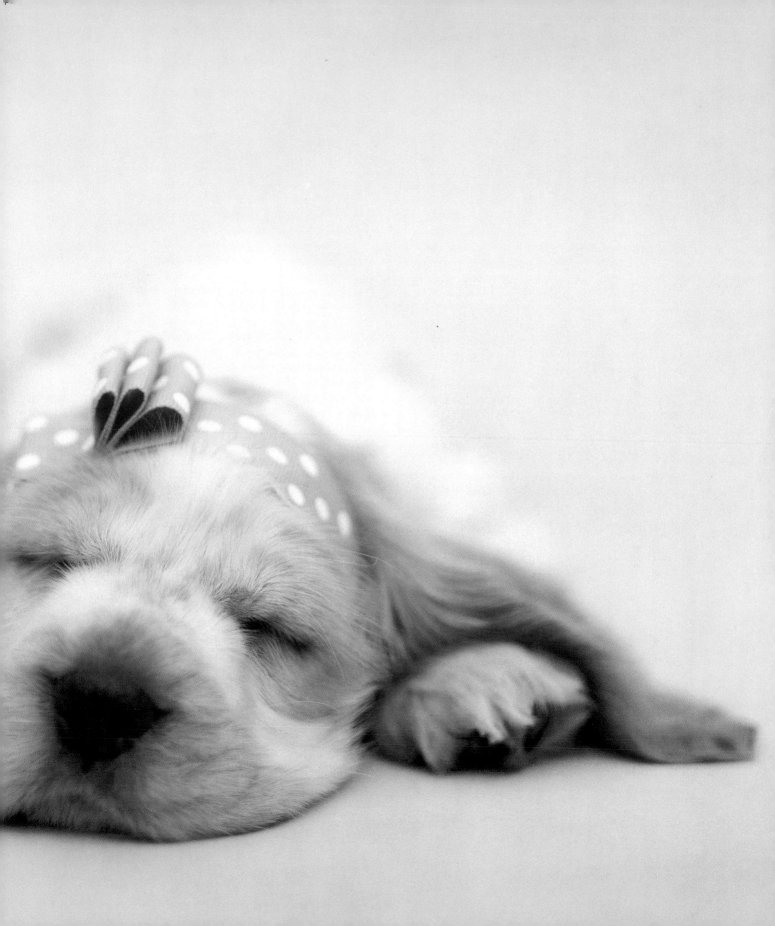

To get the full value of joy,

you must have somebody to divide it with.

MARK TWAIN

ROMEO & JULIET TOY POODLE ▶

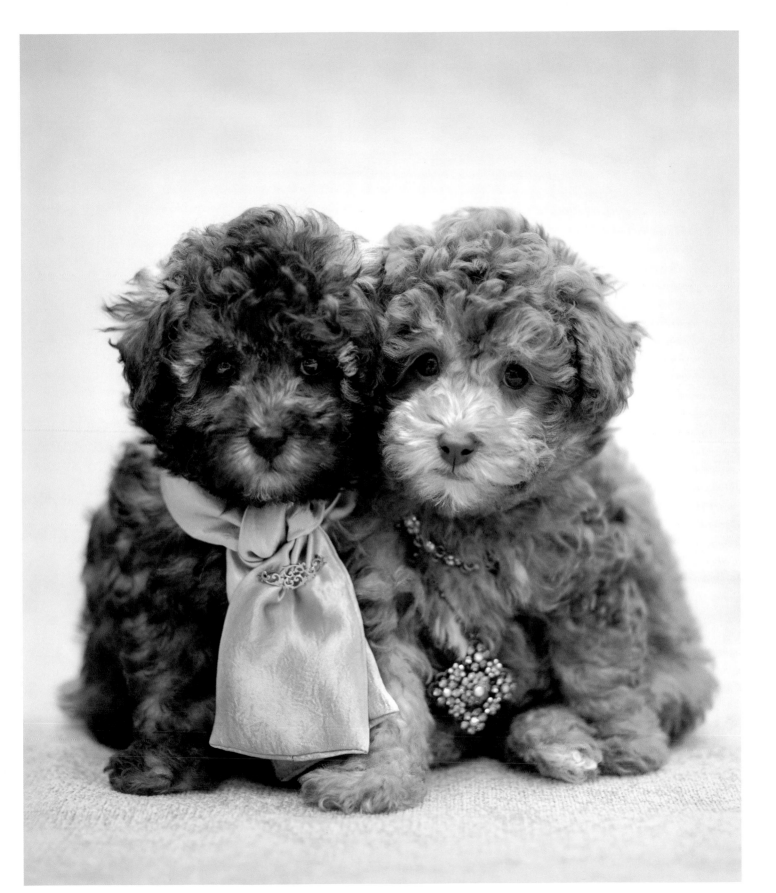

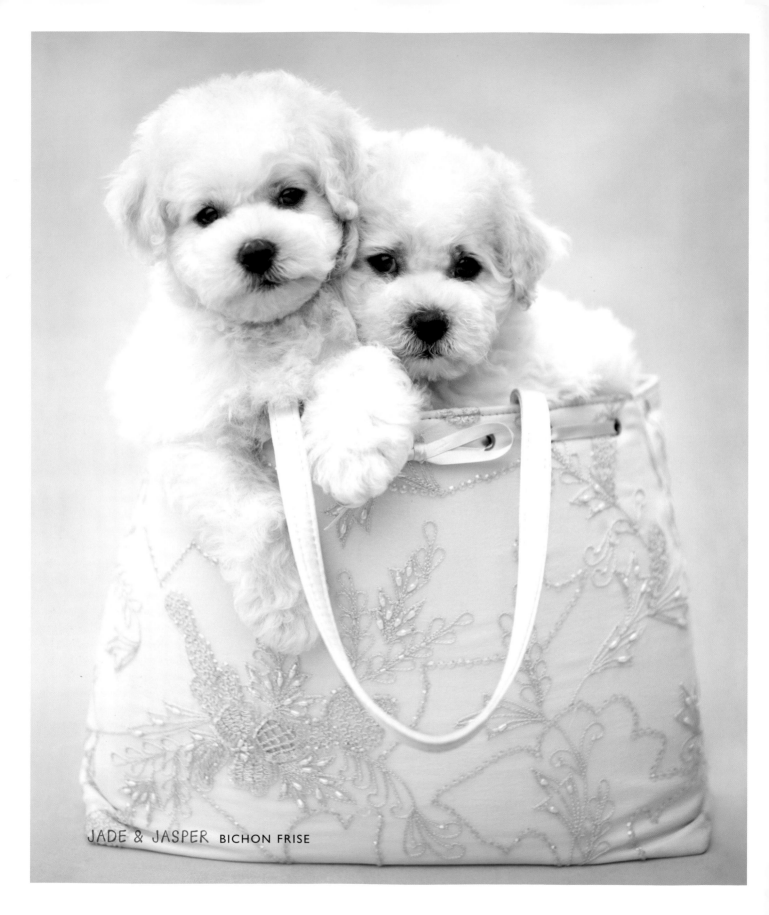

JADE & JASPER BICHON FRISE

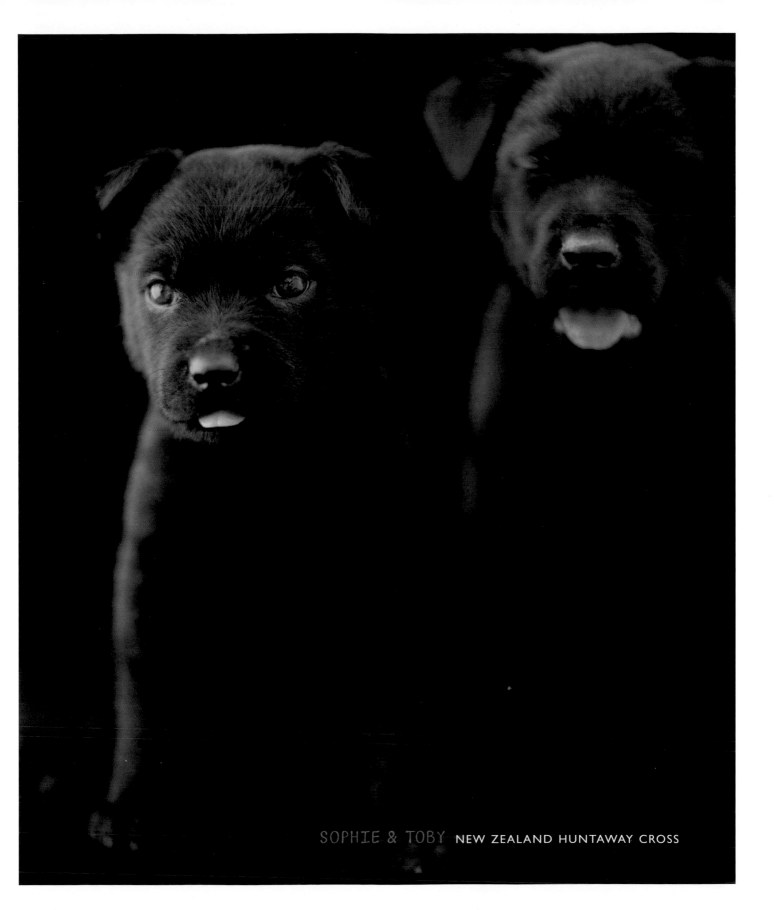

SOPHIE & TOBY NEW ZEALAND HUNTAWAY CROSS

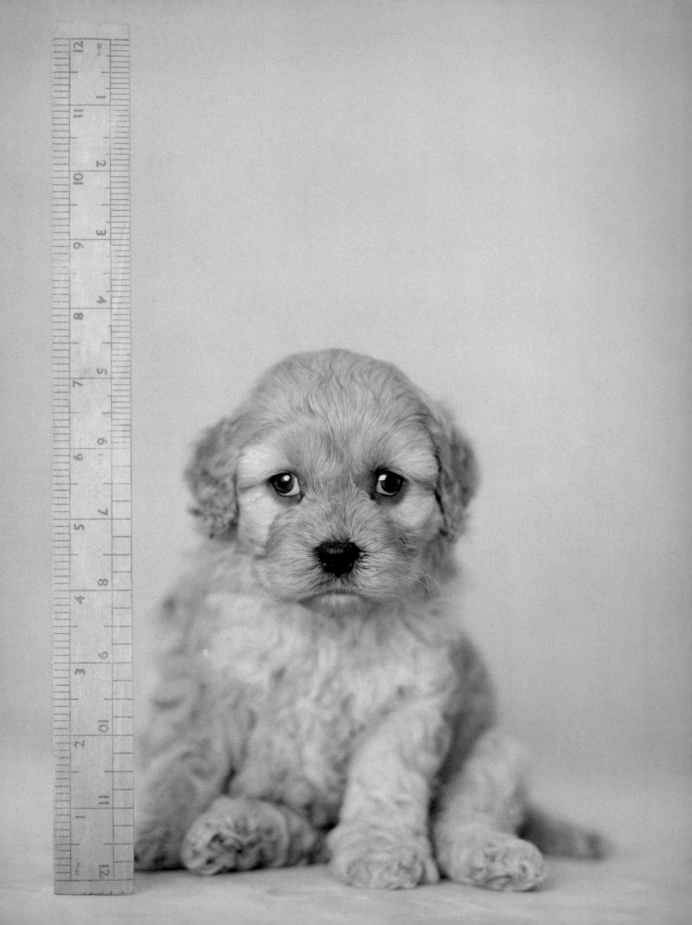

When it comes to love, size doesn't matter.

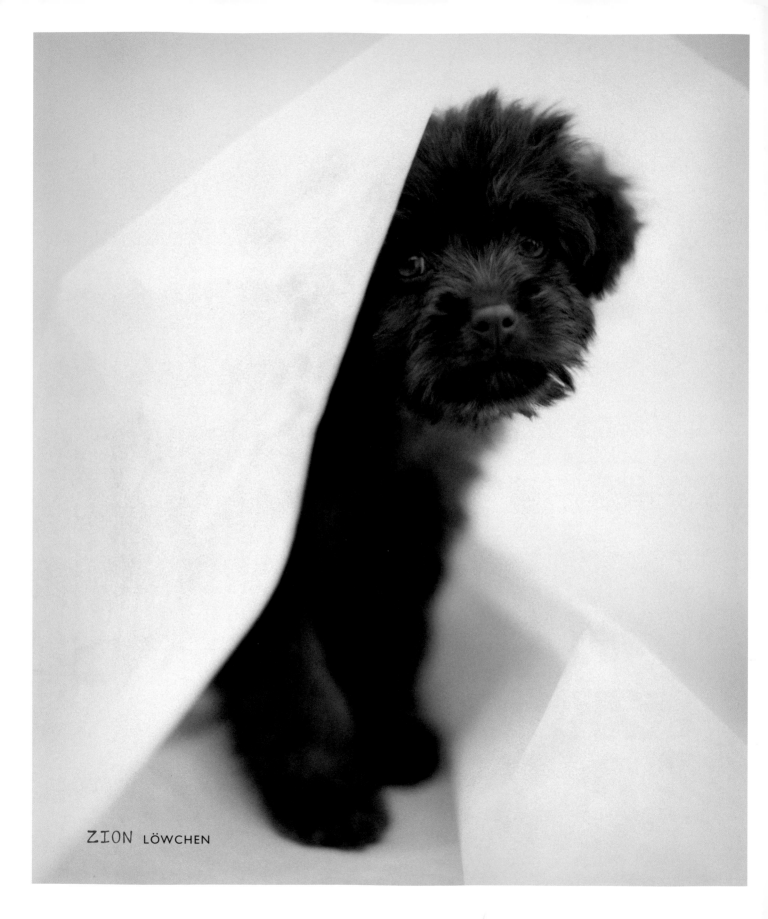

ZION LÖWCHEN

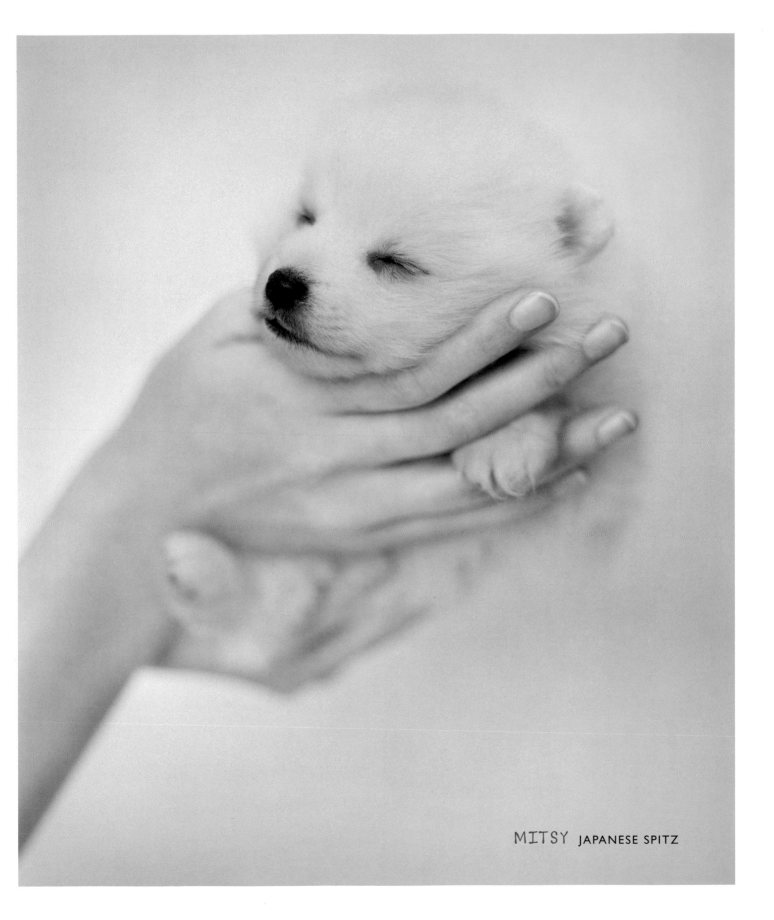

MITSY JAPANESE SPITZ

Love is like a fruit. It may look good,

but you shouldn't bite into it until it's ripe.

UNKNOWN

EMMA & CHESTER LABRADOR RETRIEVER ▶

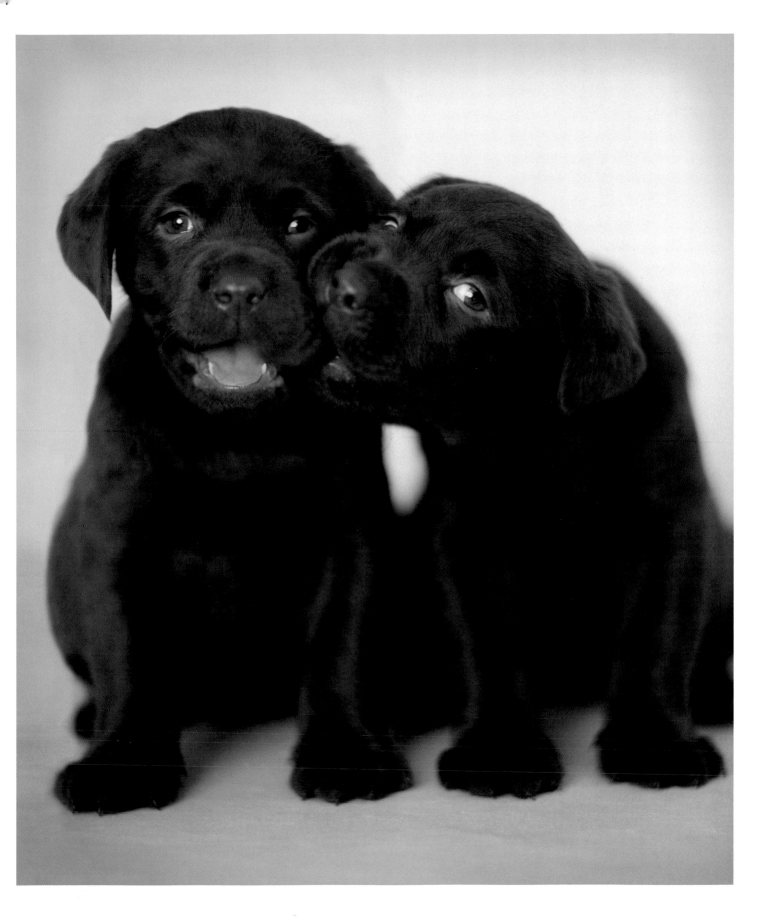

HORACE & PUGGLE **BRUSSELS GRIFFON** ▶

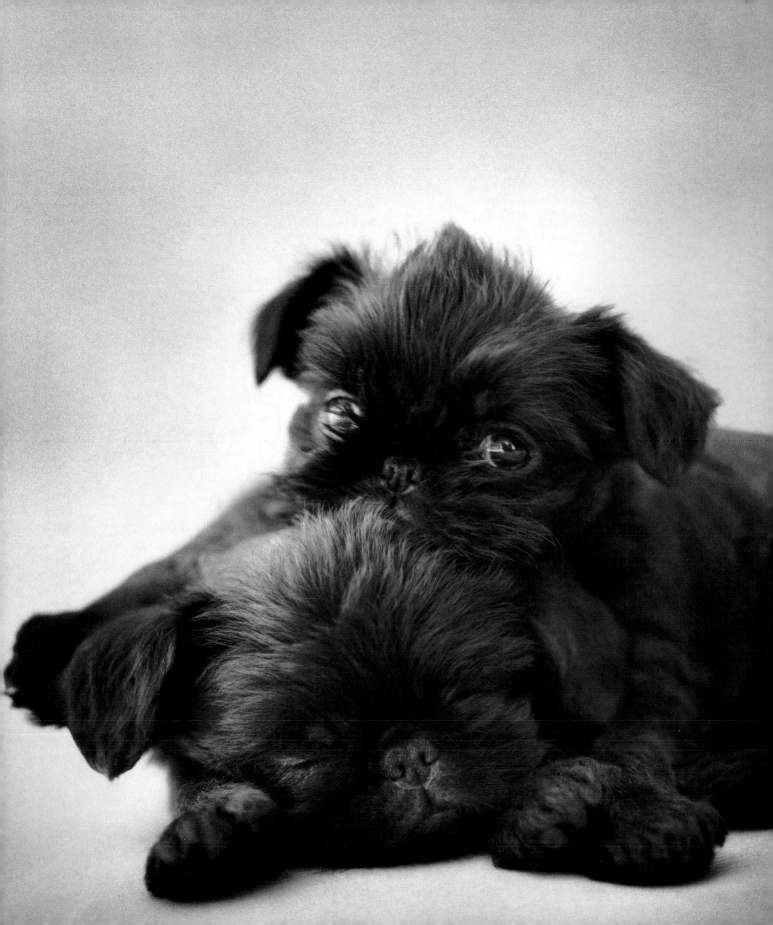

Love does not dominate...

WALLACE **LABRADOR RETRIEVER** ▶

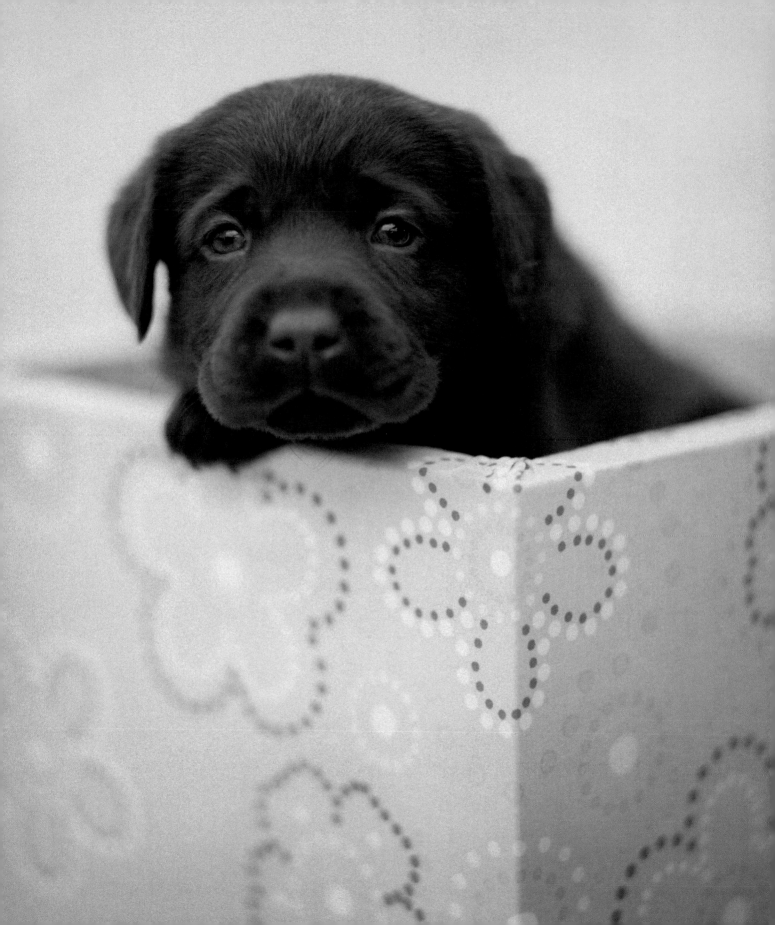

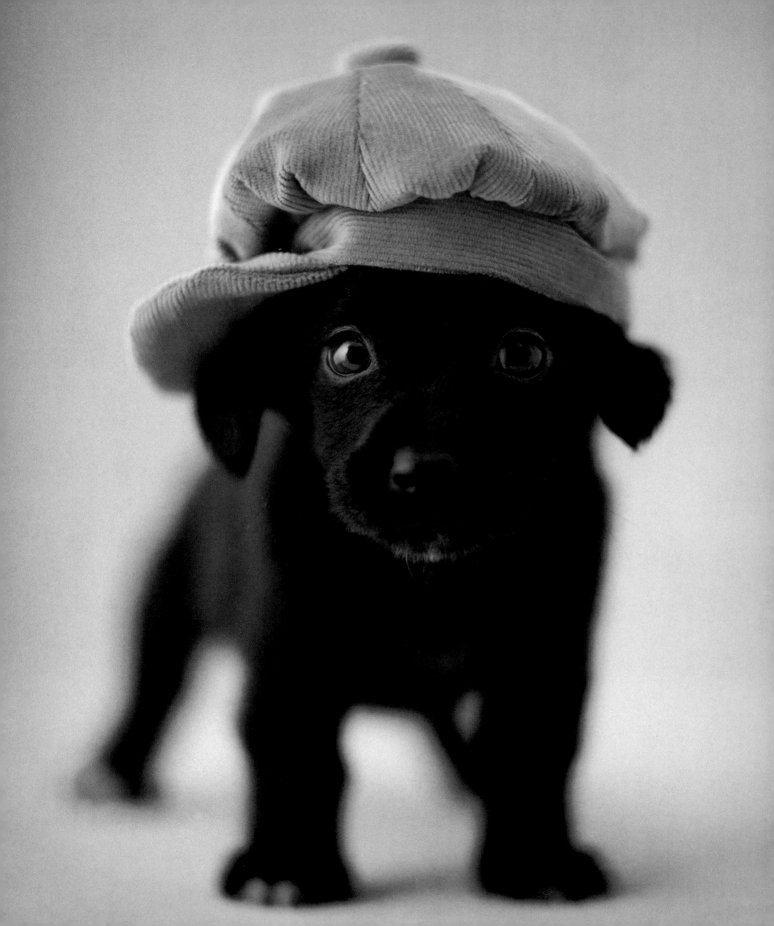

love cultivates.

JOHANN WOLFGANG VON GOETHE

What are a few words between lovers?

DOZER & ASHA LEONBERGER

MY EARLY LIFE

WINSTON S. CHURCHILL

THORNTON BUTTERWORTH

HOWITT'S RURAL LIFE OF ENGLAND.

Cyclopedia of New Zealand

Volume 5 Nelson Marlborough and Westland

The Cyclopedia Ltd.

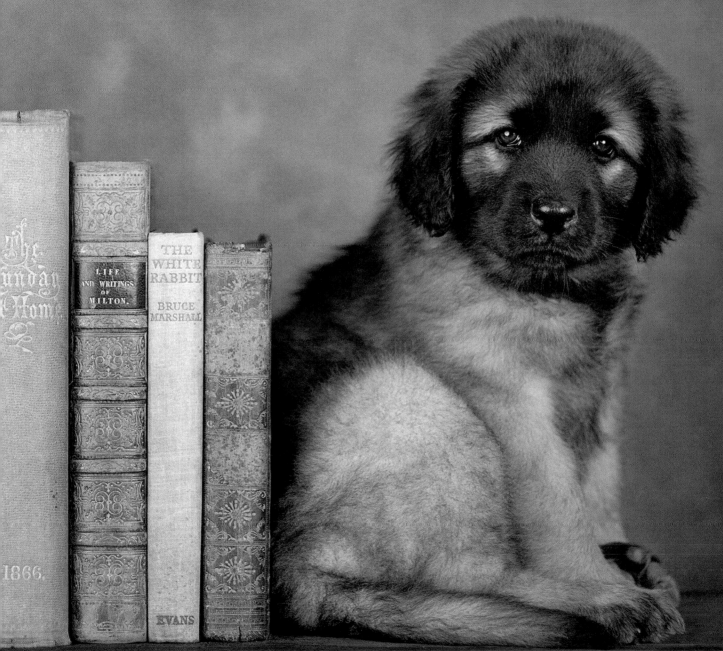

Never sleep on an argument...

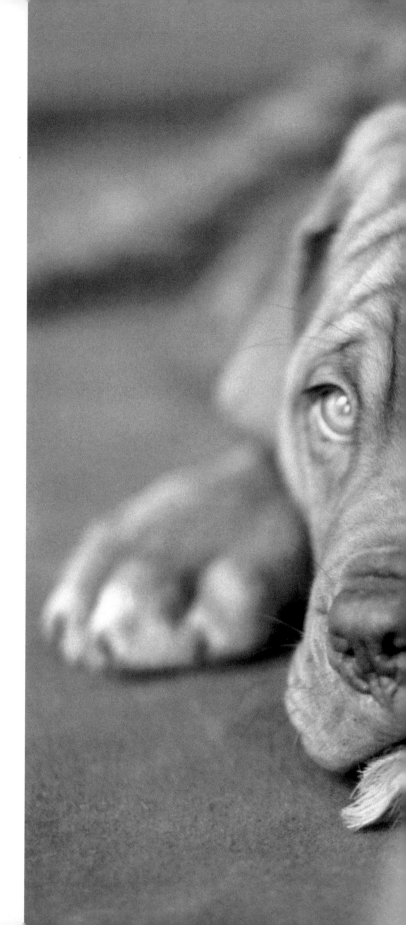

stay up and chew it over!

BOSS **DOGUE DE BORDEAUX** ▶

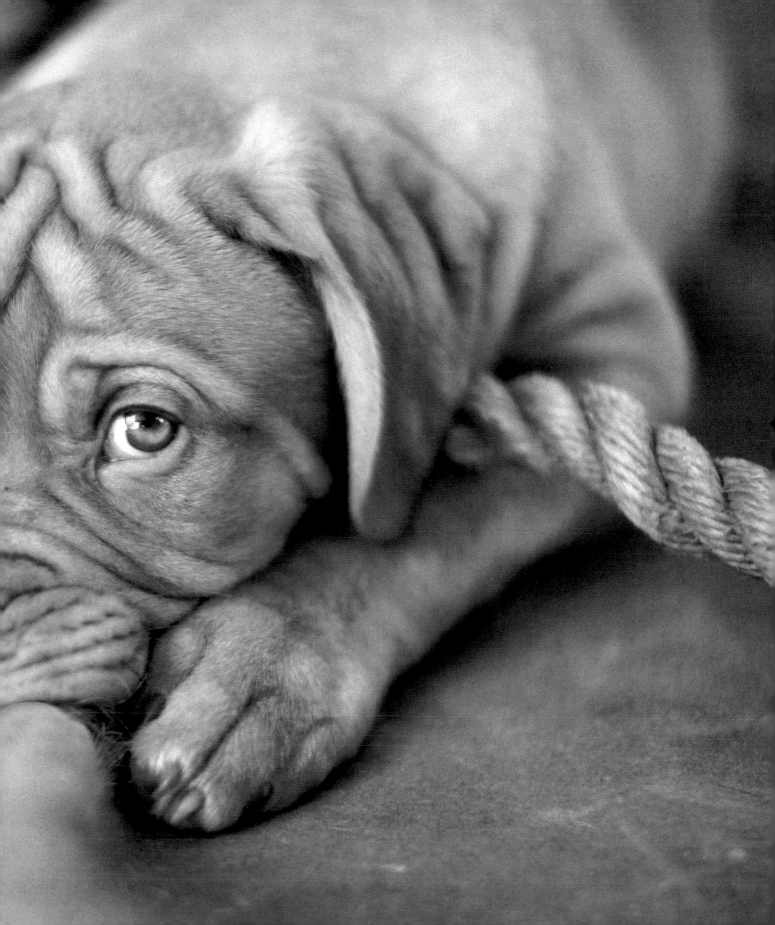

Everyone needs a plaything.

LEXIE DACHSHUND CROSS ▶

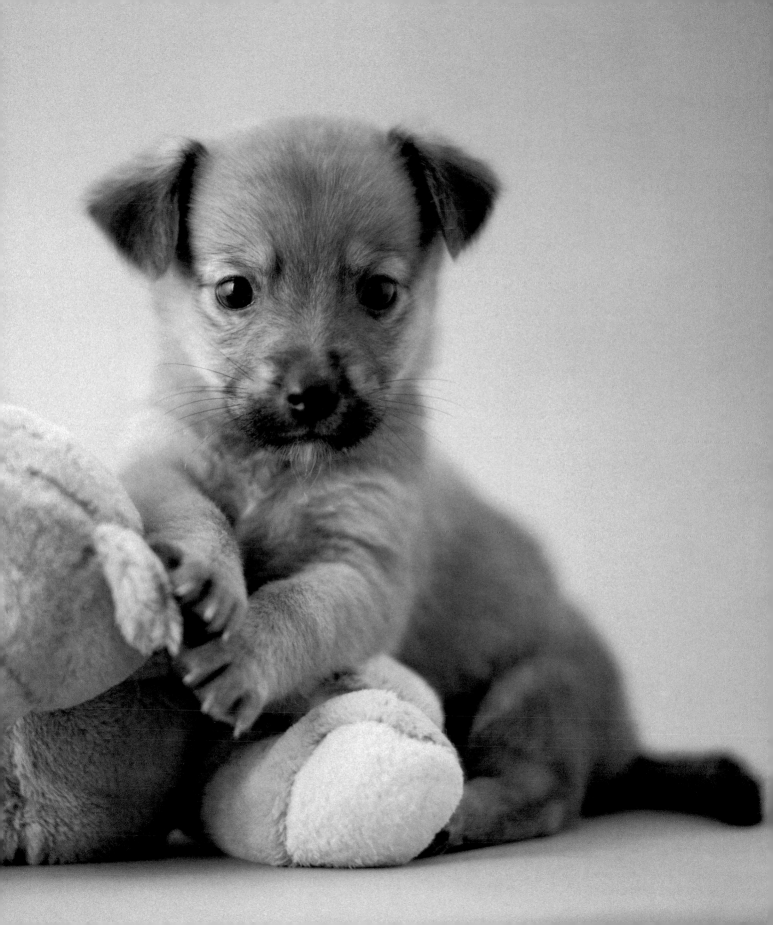

ELLY BLOODHOUND ▶

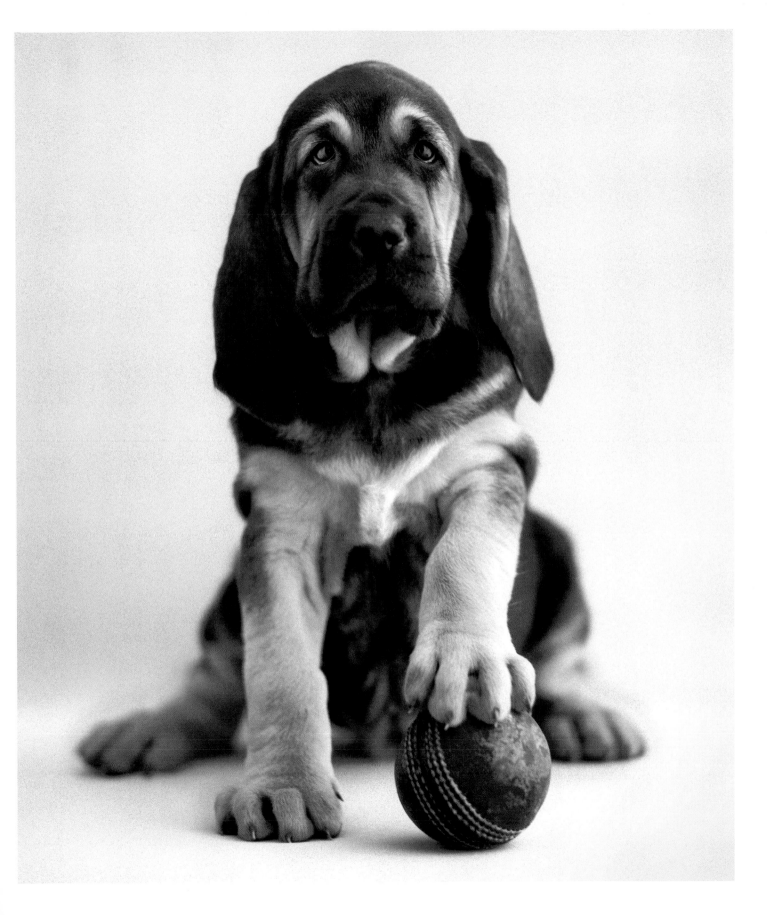

Love does not consist in gazing at each other,

but in looking outward together in the same direction.

ANTOINE DE SAINT-EXUPÉRY

COCO & SHILO DOGUE DE BORDEAUX ▶

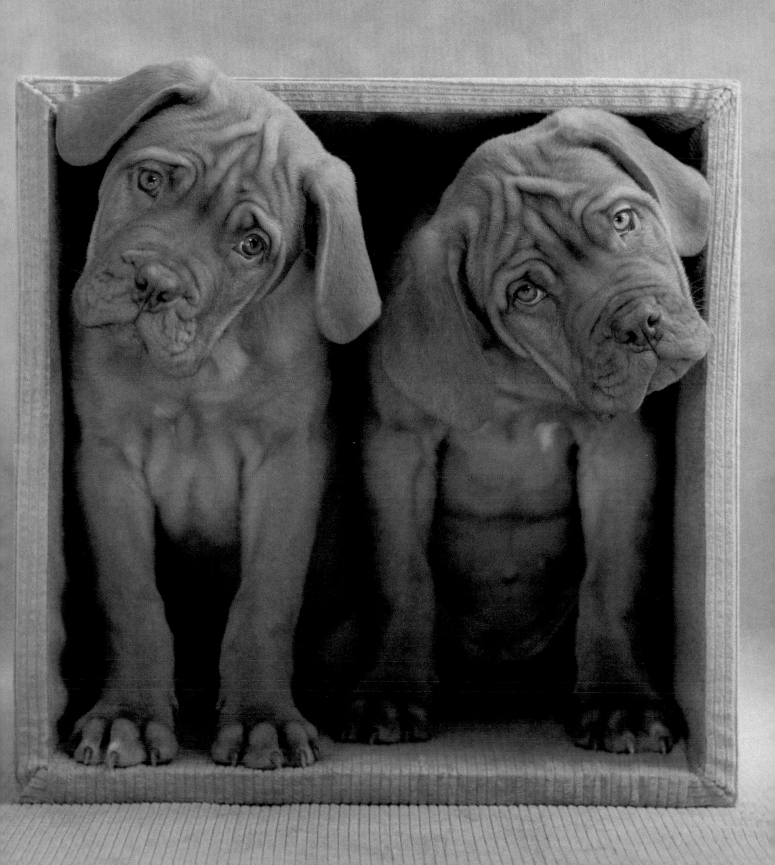

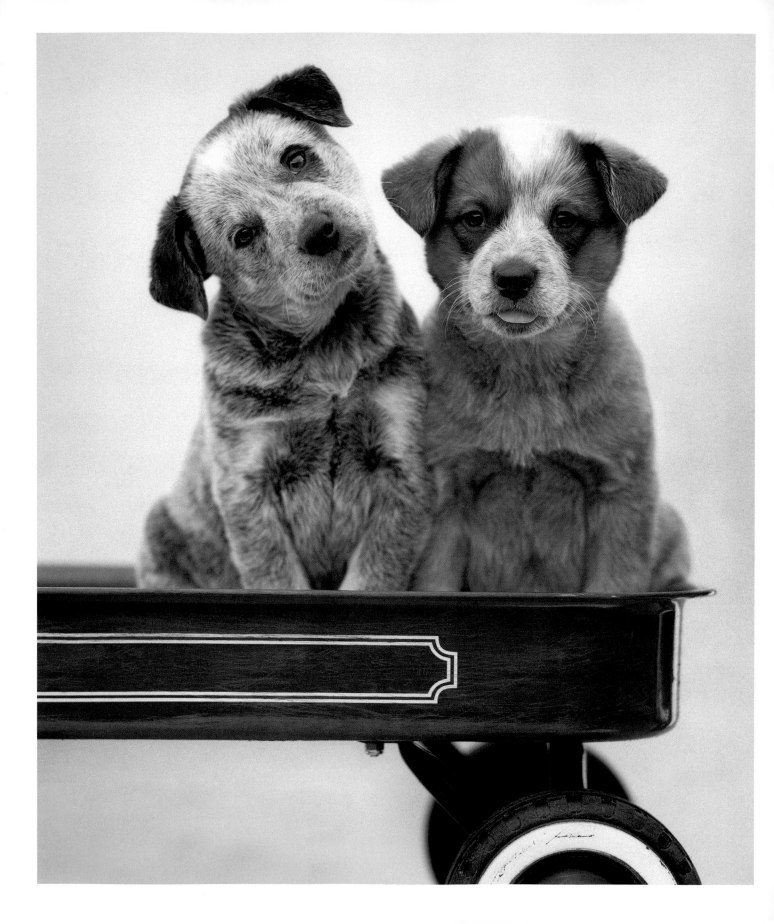

When it comes to romance, two's company...

three's a crowd.

ADAGE

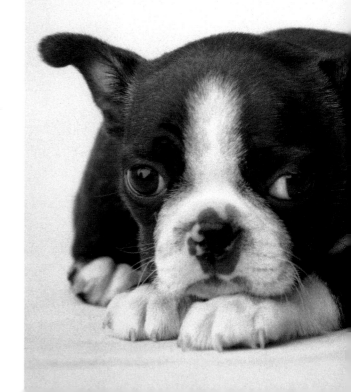

RUBY, HOTAI & MILLY
BOSTON TERRIER ▶

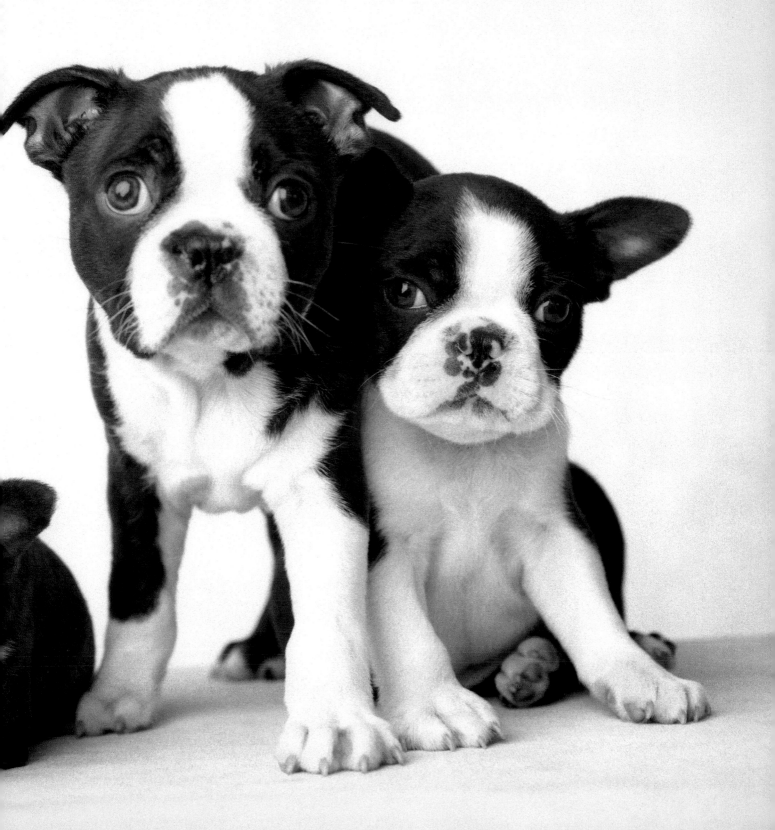

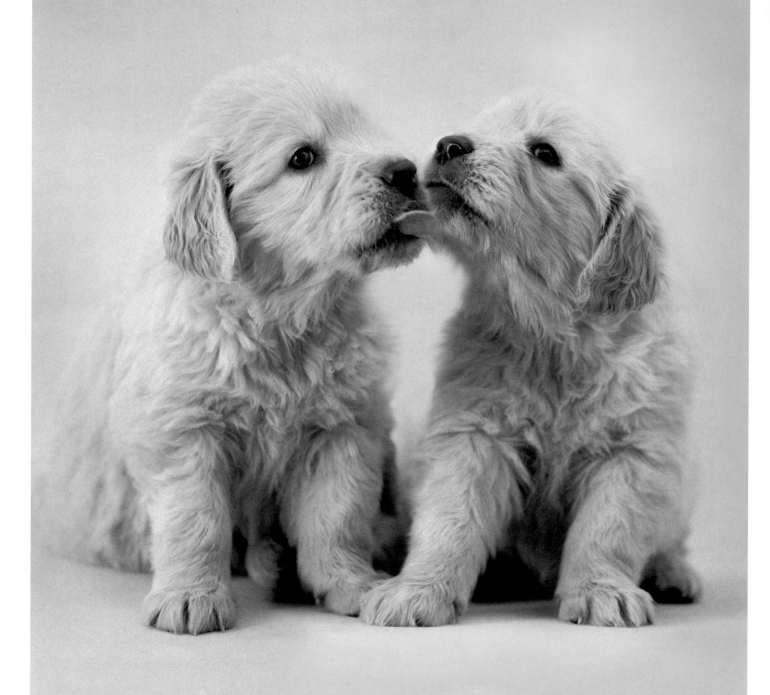

Anyone can be passionate...

but it takes real lovers to be silly.

ROSE FRANKEN

CHARLIE WEST HIGHLAND WHITE TERRIER ▶

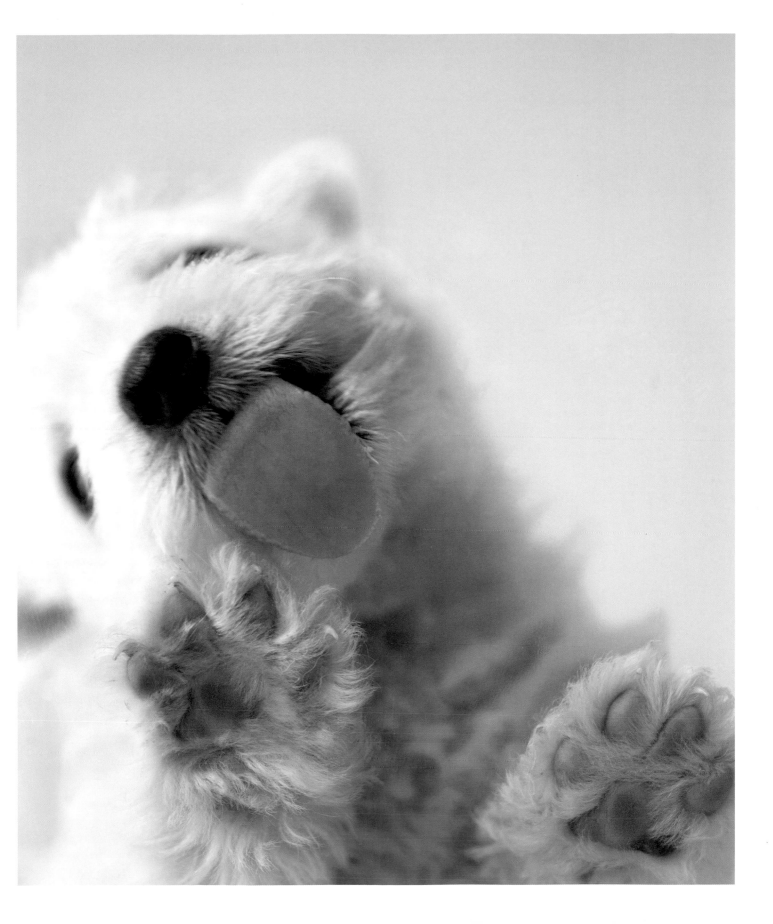

A heart that loves is always young.

GREEK PROVERB

BELLA BICHON FRISE CROSS ▶

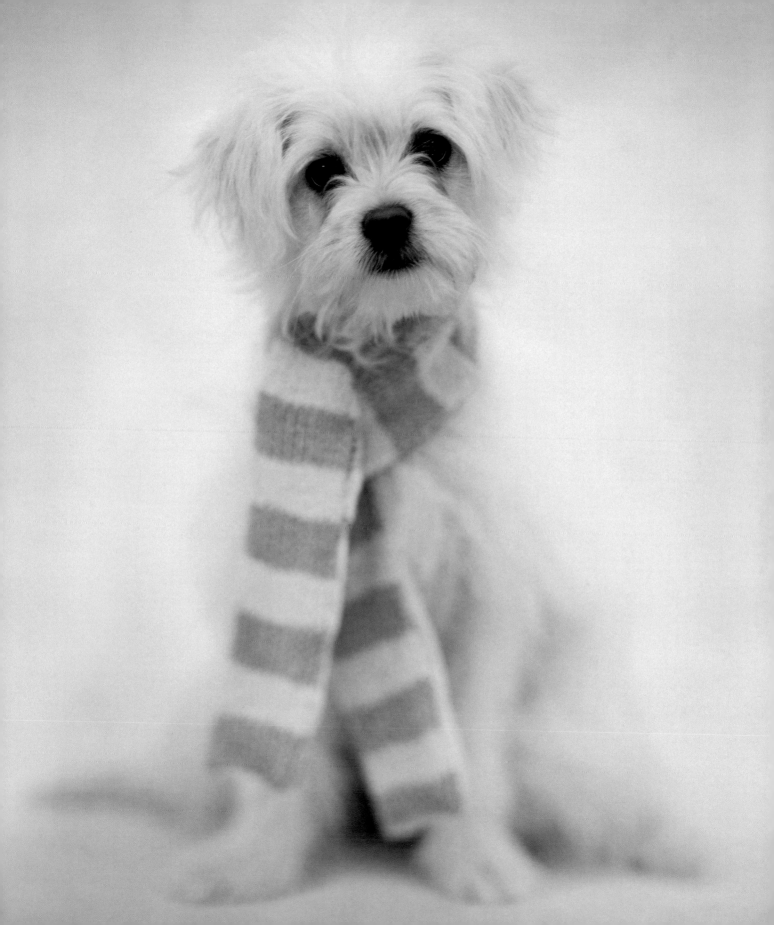

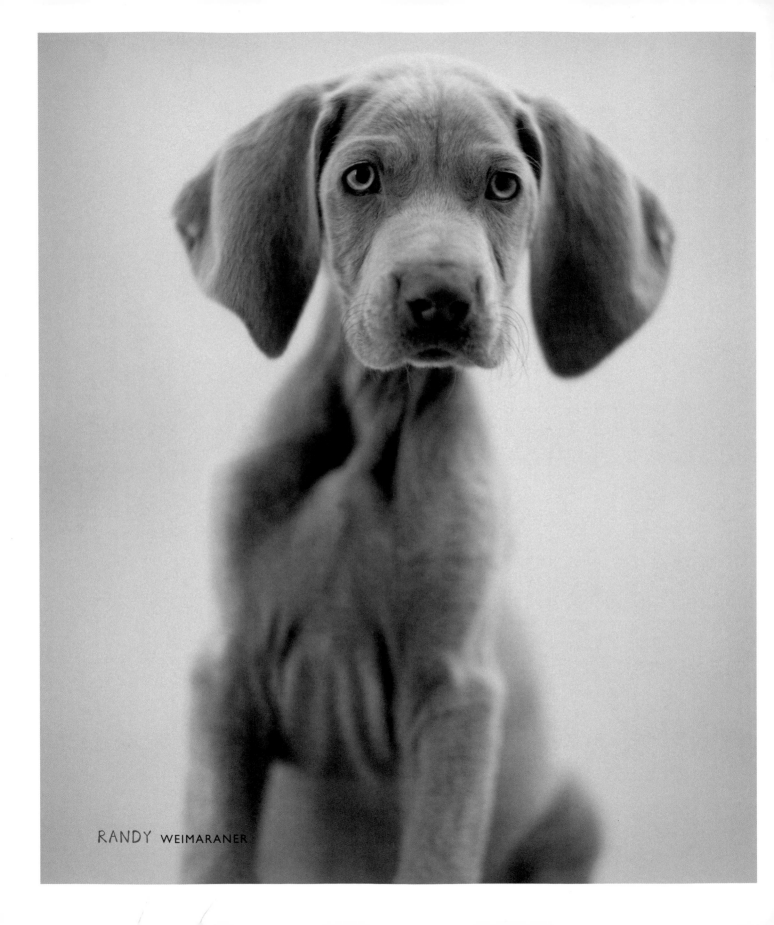

RANDY WEIMARANER

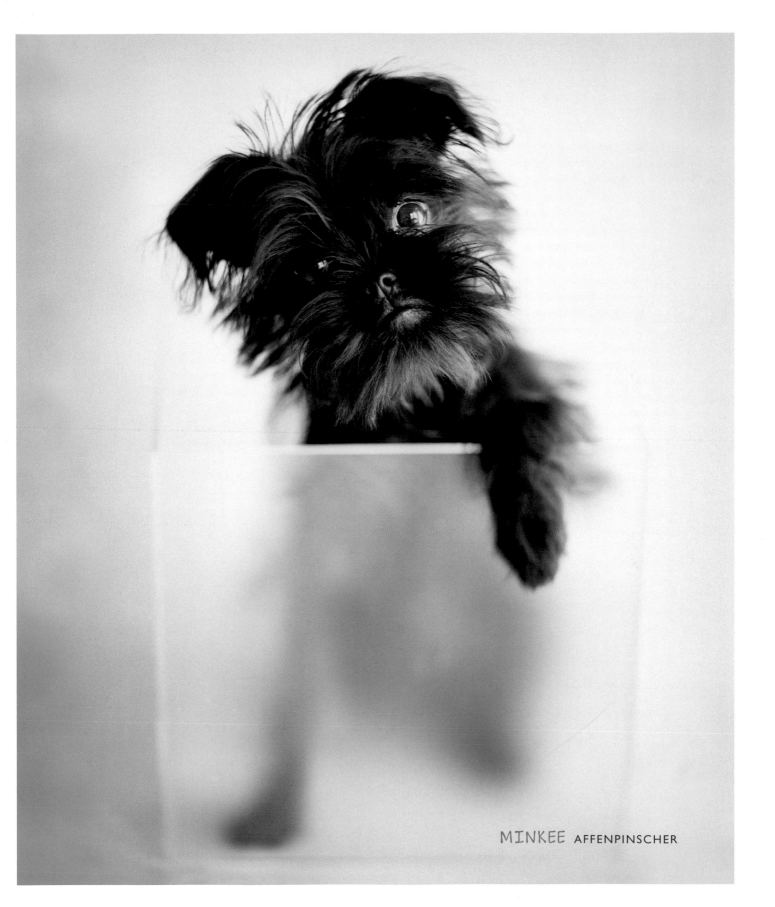

MINKEE AFFENPINSCHER

TURBO BLOODHOUND ▶

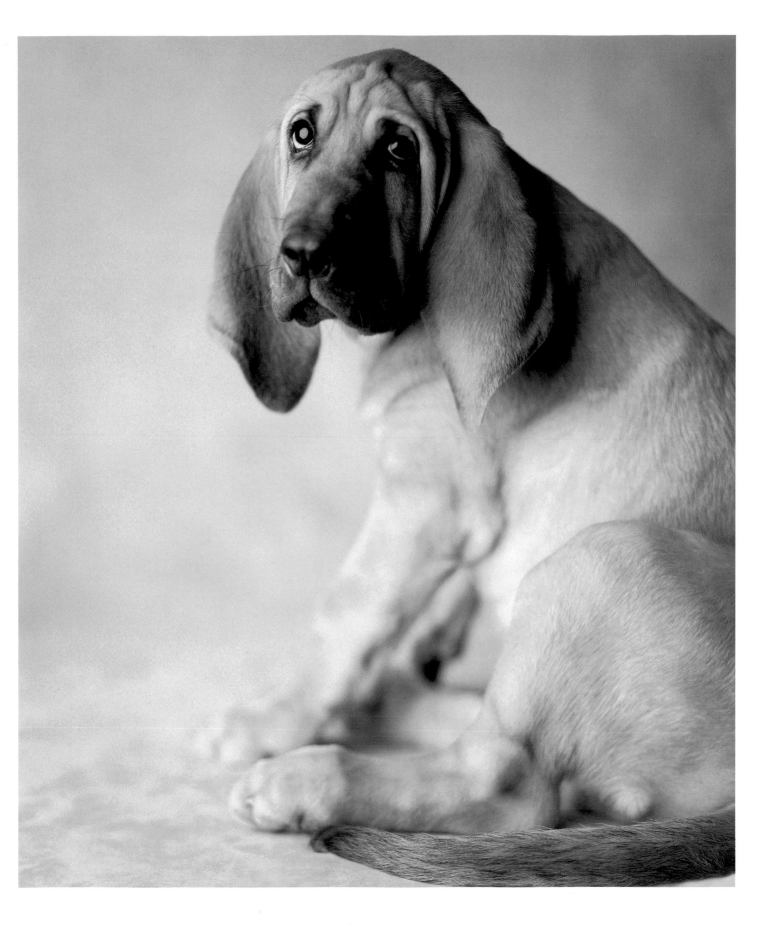

Truc love stories never have endings.

RICHARD BACH

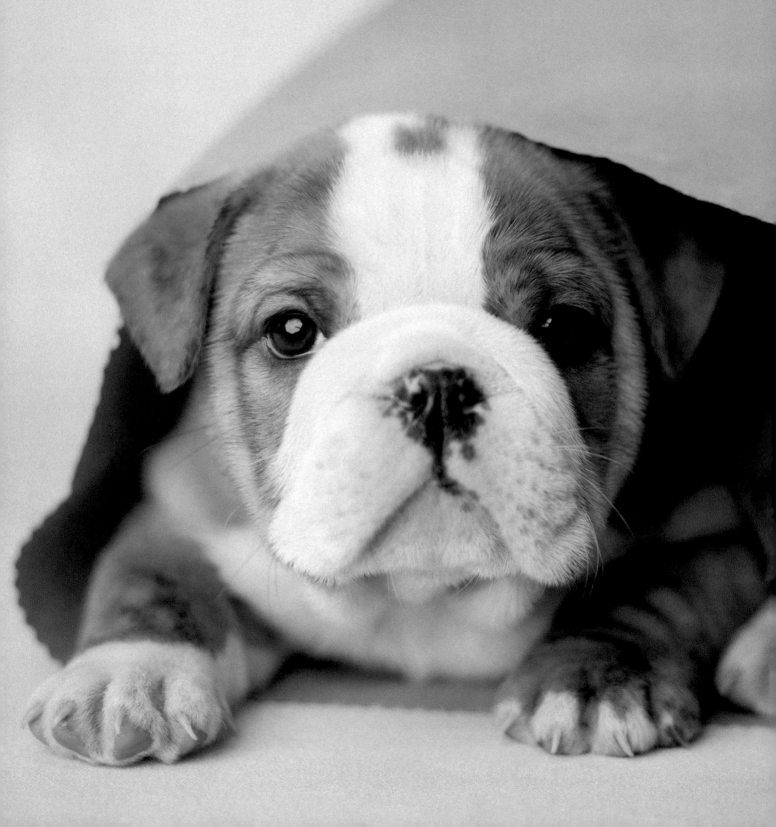

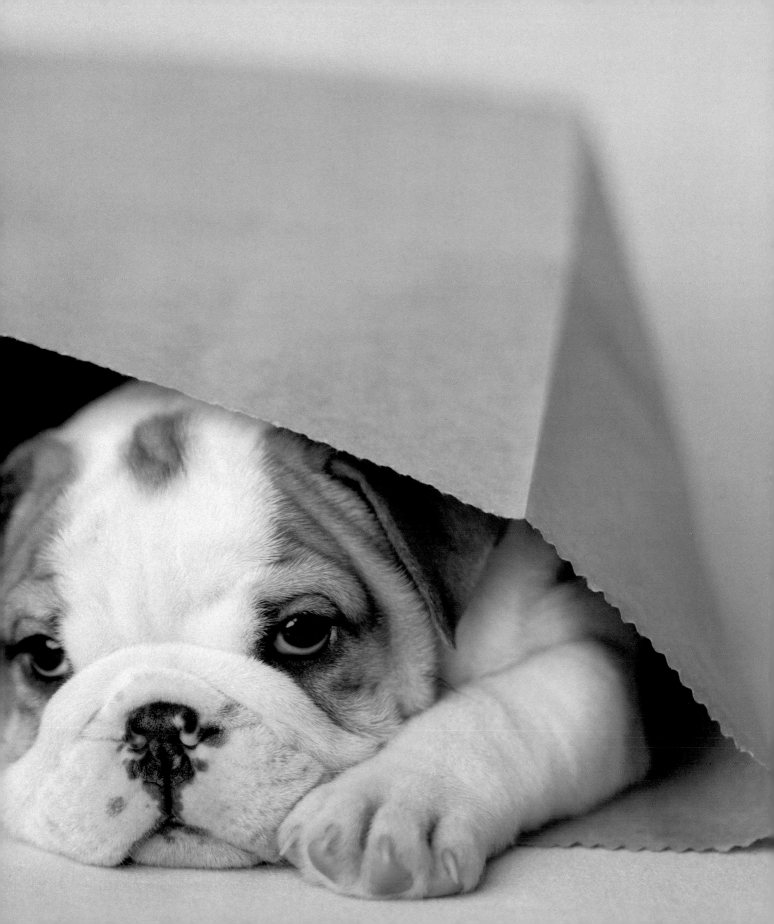

TUCKER & MILLY CAIRN TERRIER ▶

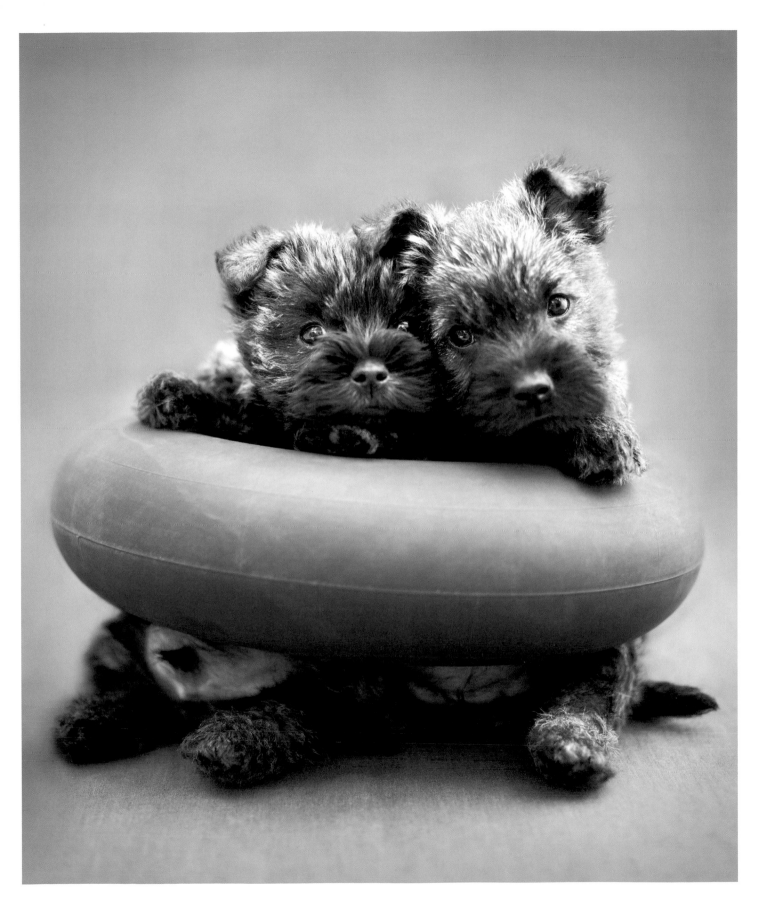

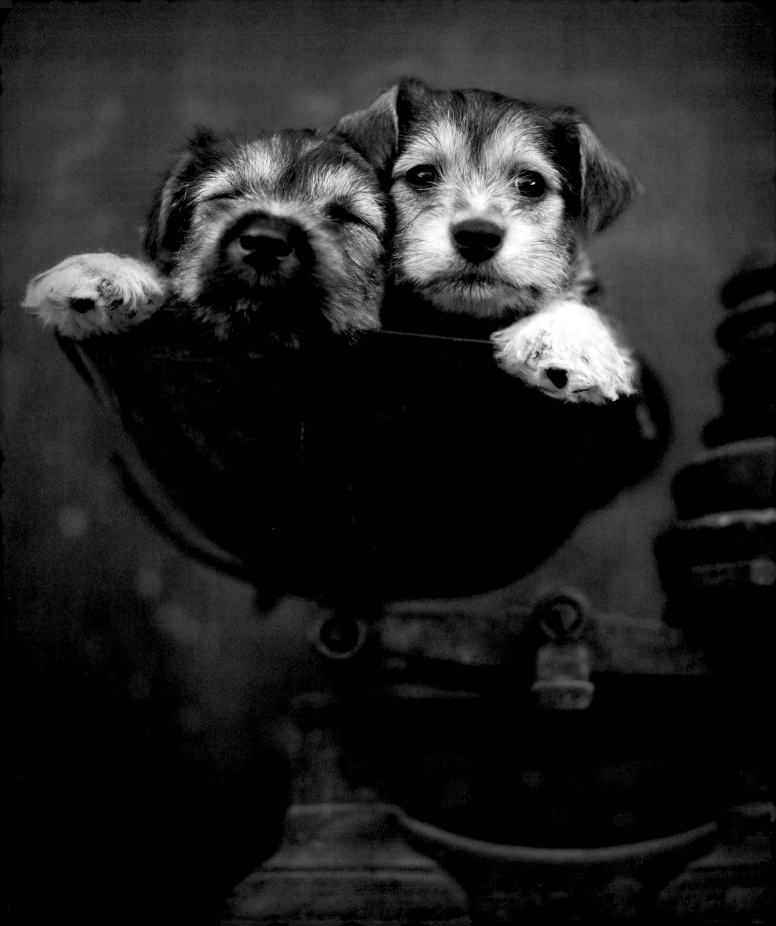

In the arithmetic of love, one plus one equals everything,

and two minus one equals nothing.

MIGNON MCLAUGHLIN

DALI BRUSSELS GRIFFON ▶

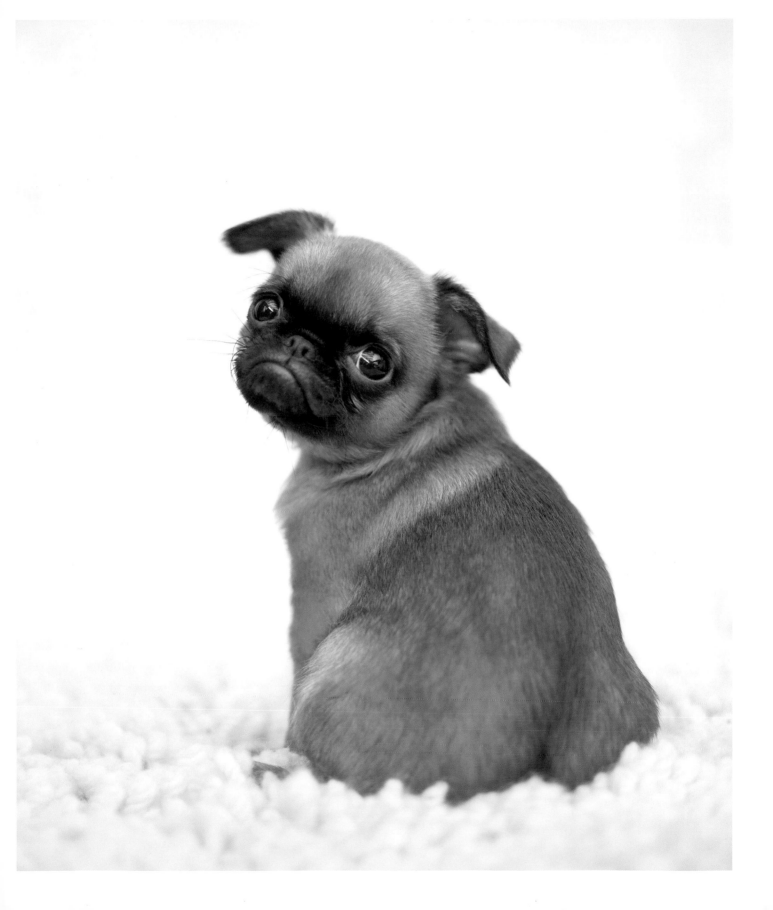

What the world really needs

is more love and less paperwork.

PEARL BAILEY

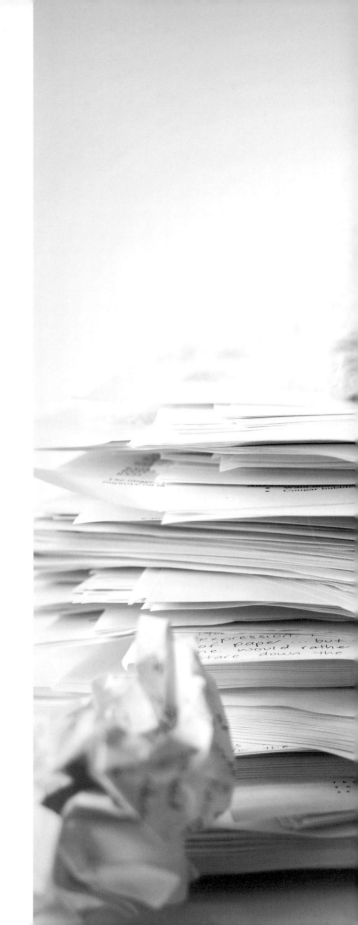

CODY & CARTER

WEST HIGHLAND WHITE TERRIER ▶

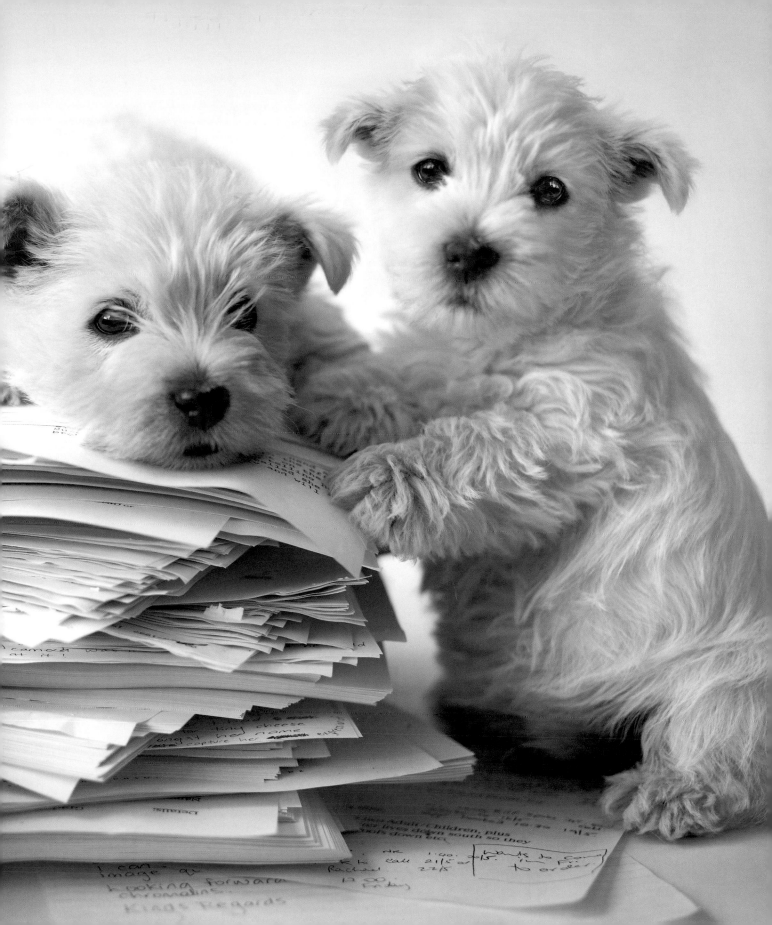

Seize the moments of happiness, love and be loved!

LEO TOLSTOY

BOXER, RANDY & BLACK WEIMARANER ▶

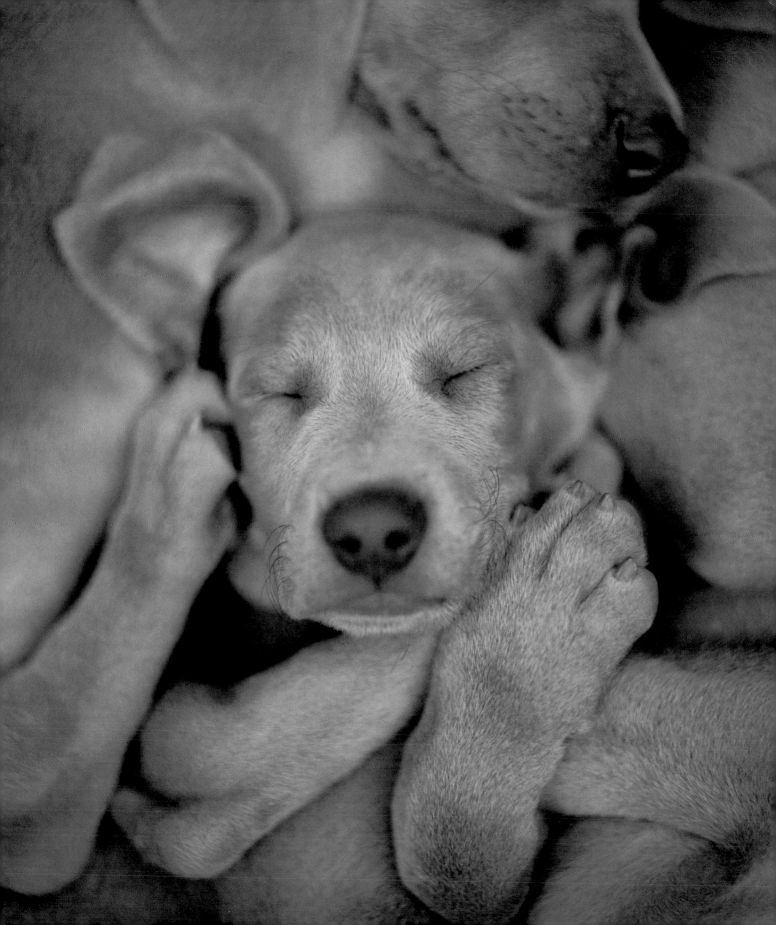

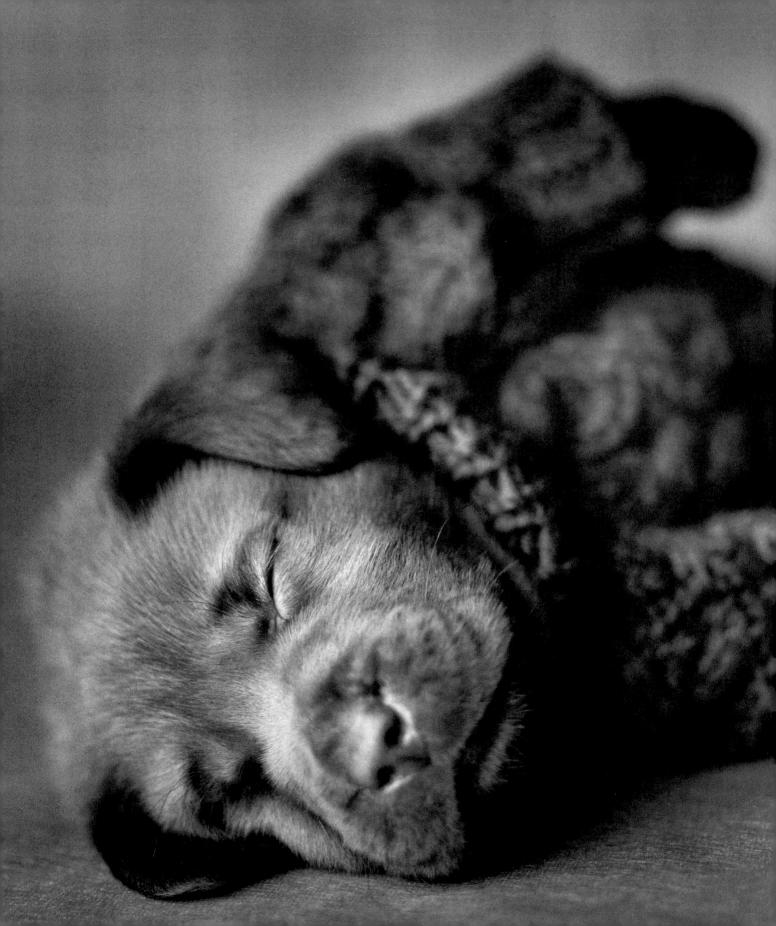

Nothing takes the taste out of peanut butter

quite like unrequited love.

CHARLIE BROWN

FLEUR PARSON RUSSELL TERRIER CROSS ▶

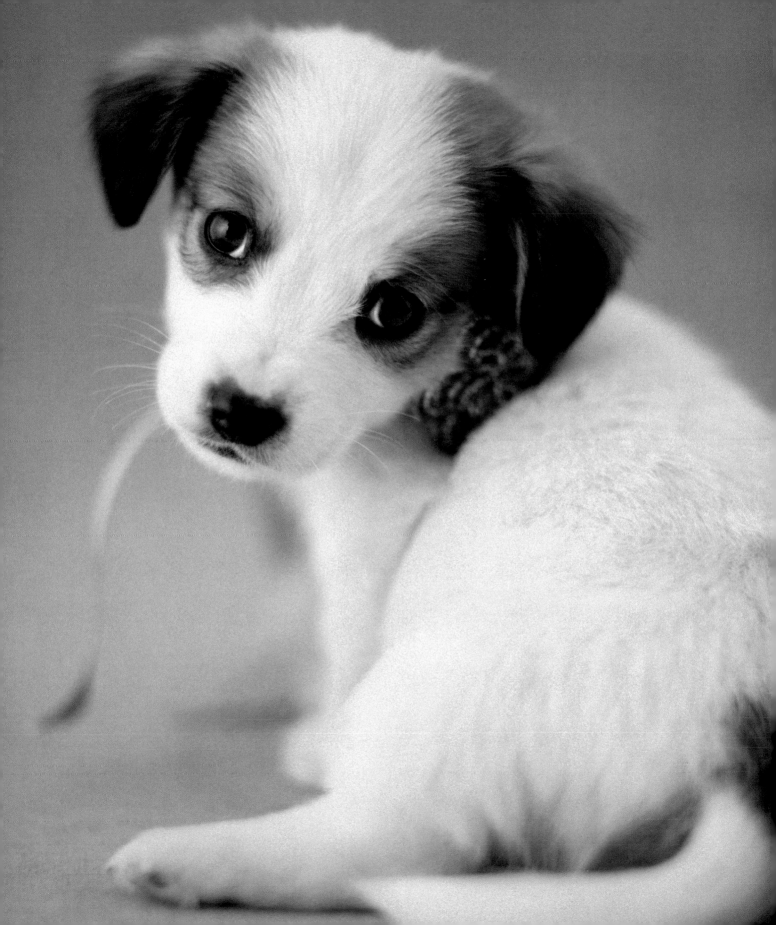

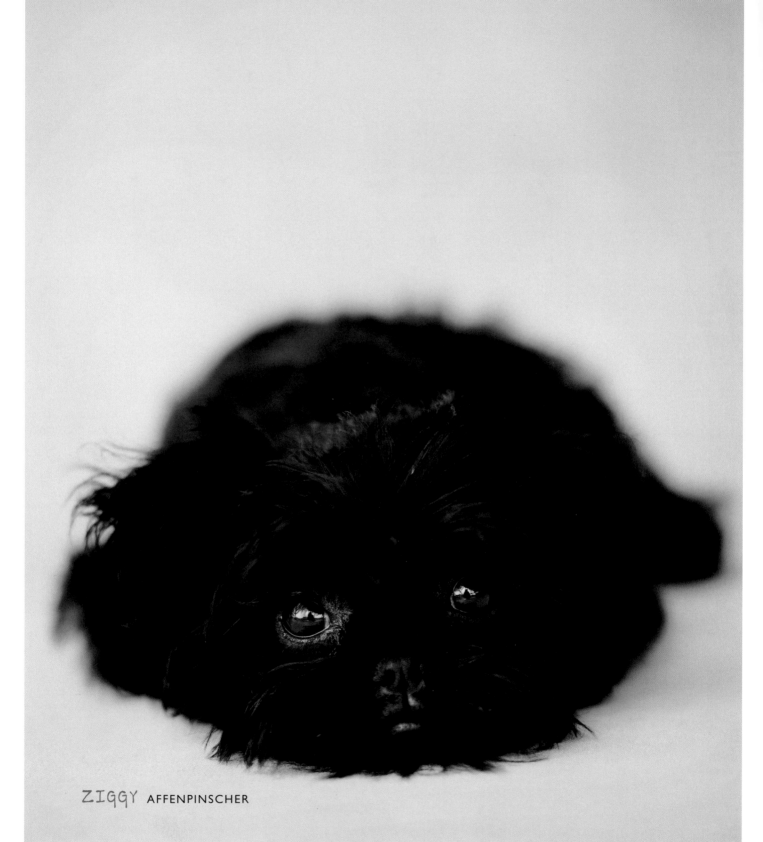

ZIGGY AFFENPINSCHER

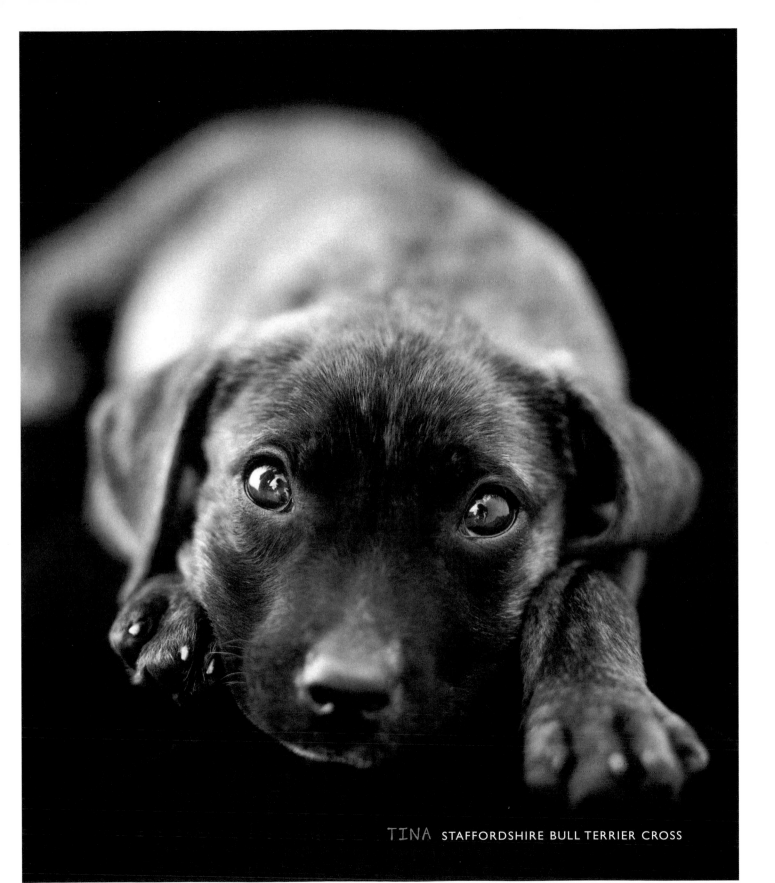

TINA STAFFORDSHIRE BULL TERRIER CROSS

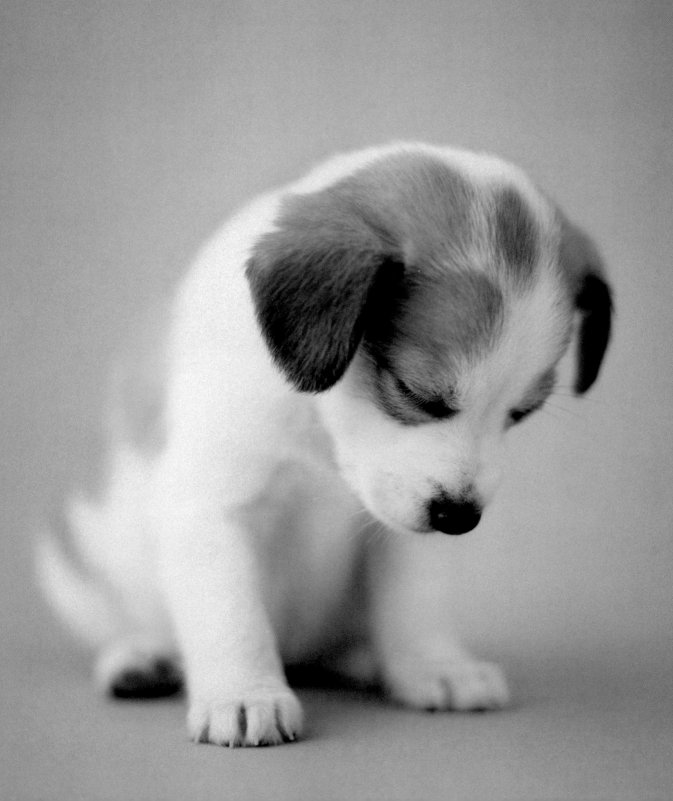

You can't blame gravity for falling in love.

ALBERT EINSTEIN

◄ BART PARSON RUSSELL TERRIER CROSS

SMOKE BLOODHOUND ▶

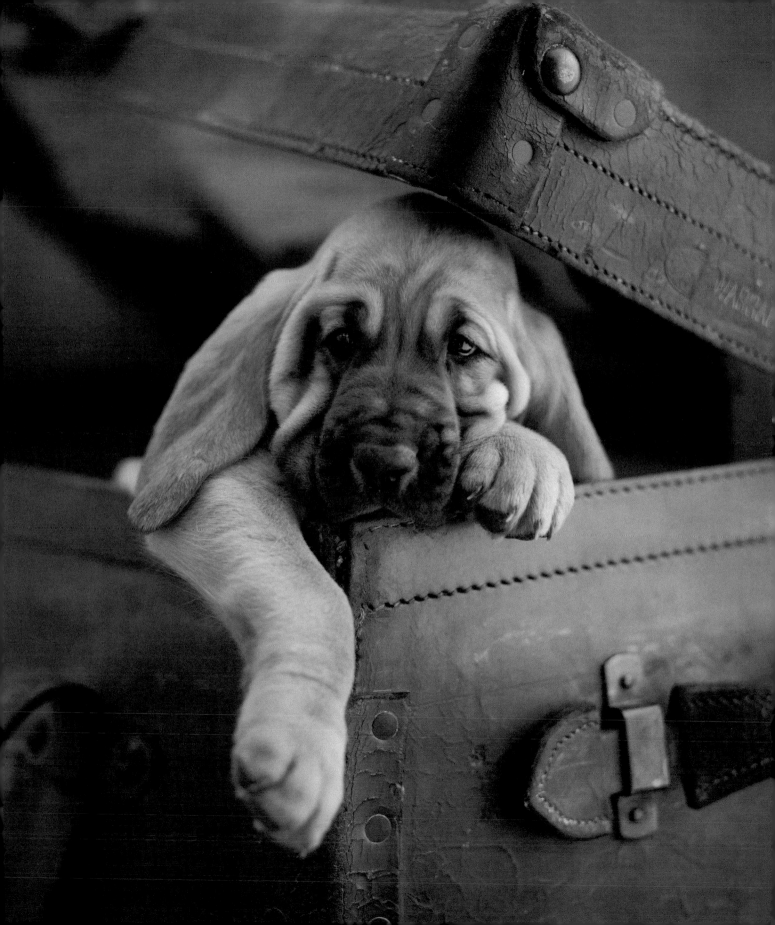

Love doesn't make the world go round,

love is what makes the ride worthwhile.

ELIZABETH BARRETT BROWNING

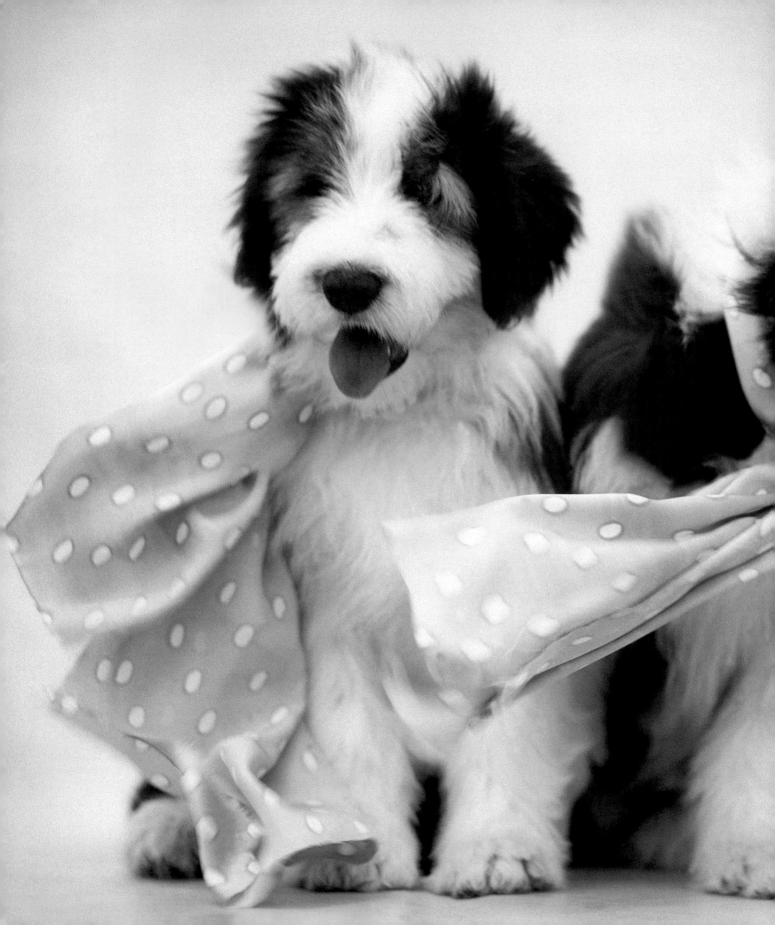

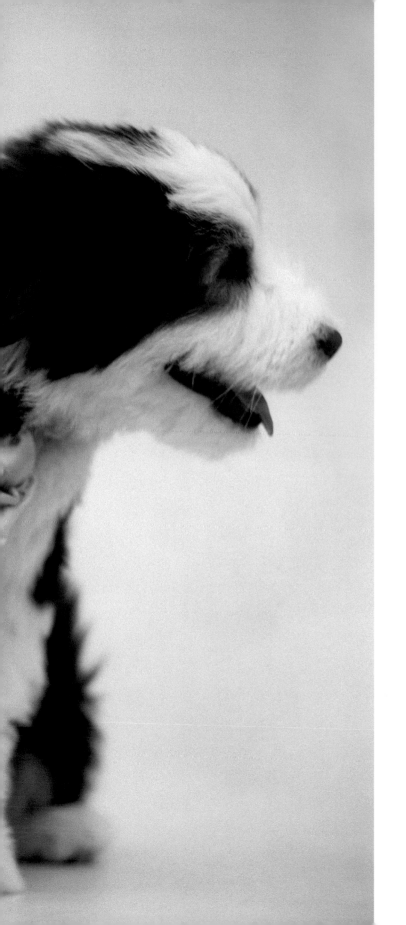

◄ LIZZIE & PIPER

BEARDED COLLIE

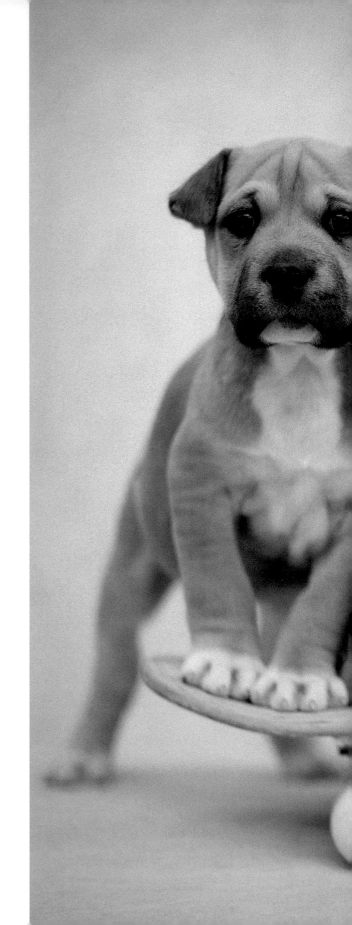

EENEY, MEENY, MINEY & MO

STAFFORDSHIRE BULL TERRIER CROSS ▶

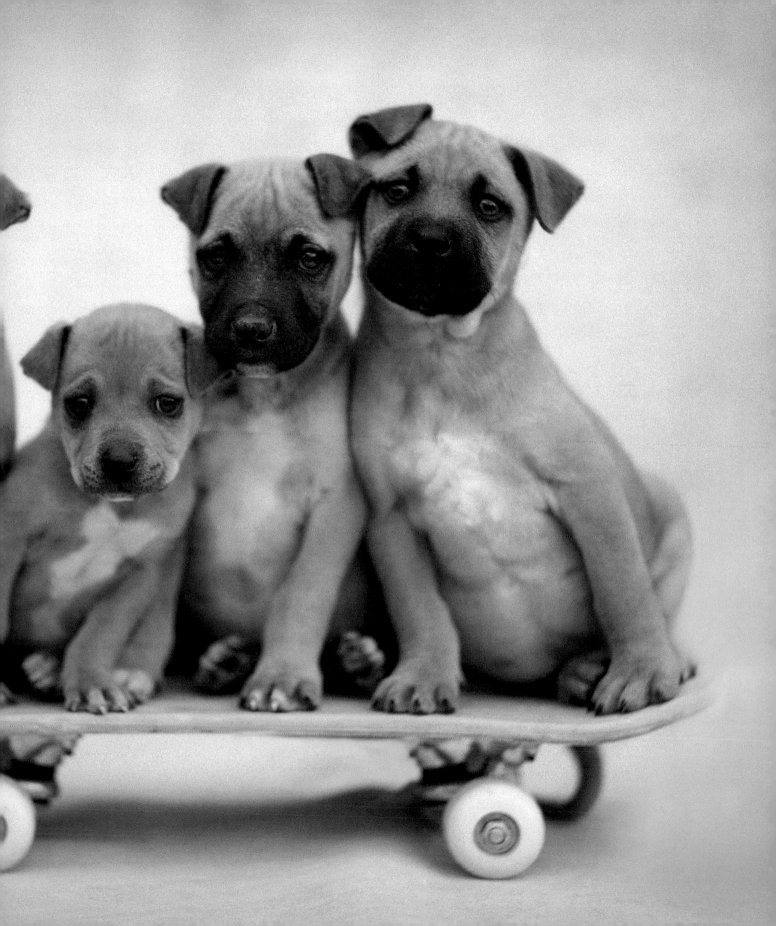

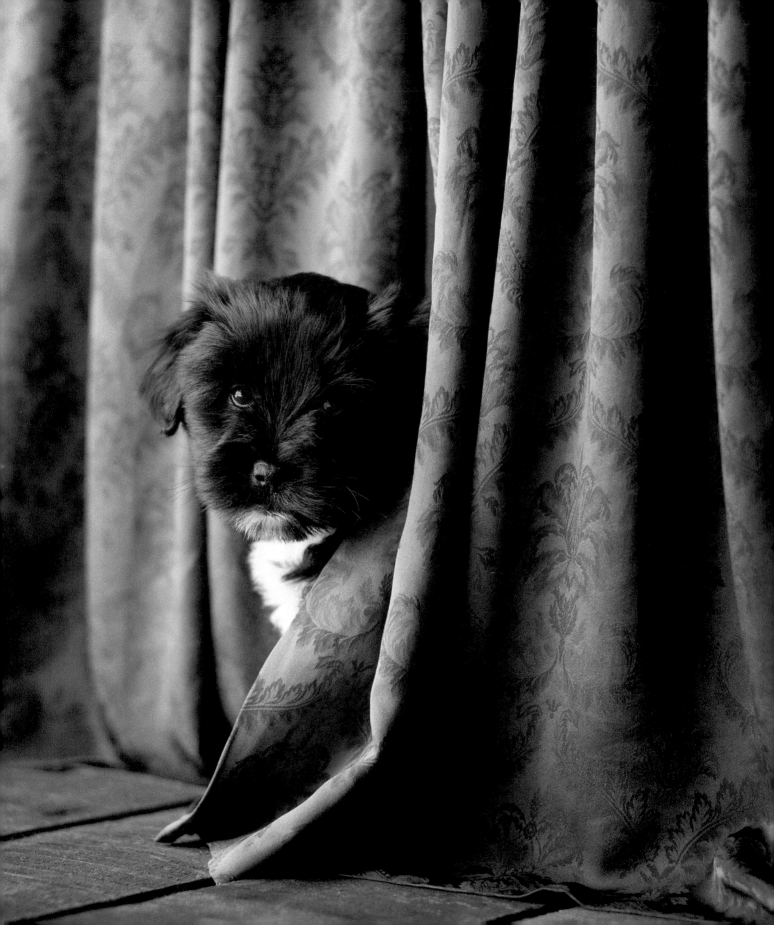

Good things come to those who wait.

PROVERB

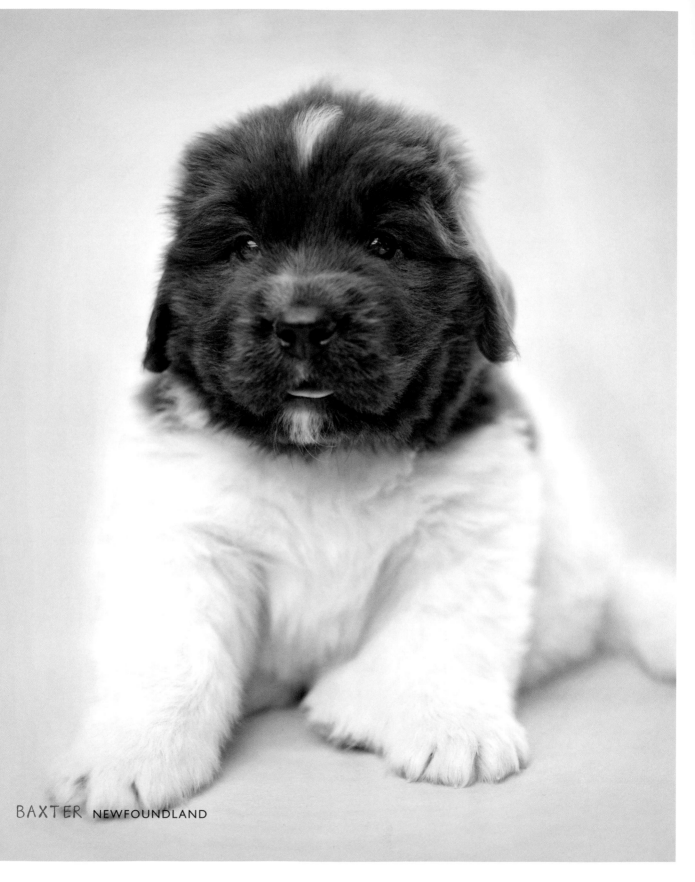

BAXTER NEWFOUNDLAND

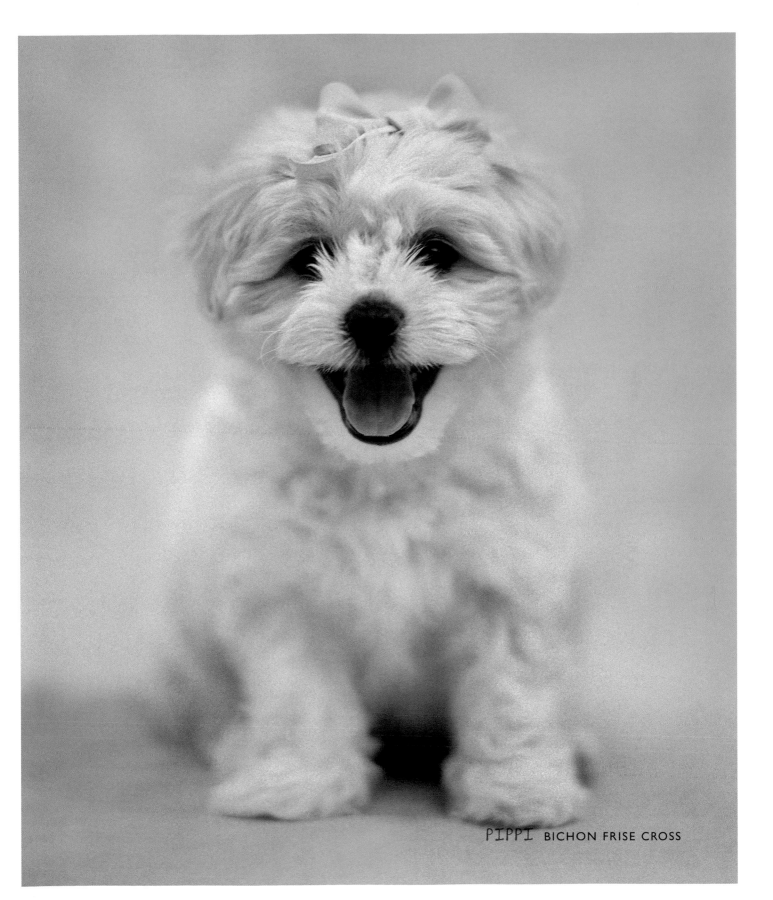

PIPPI BICHON FRISE CROSS

OSCAR & MAYSIE LABRADOR RETRIEVER ▶

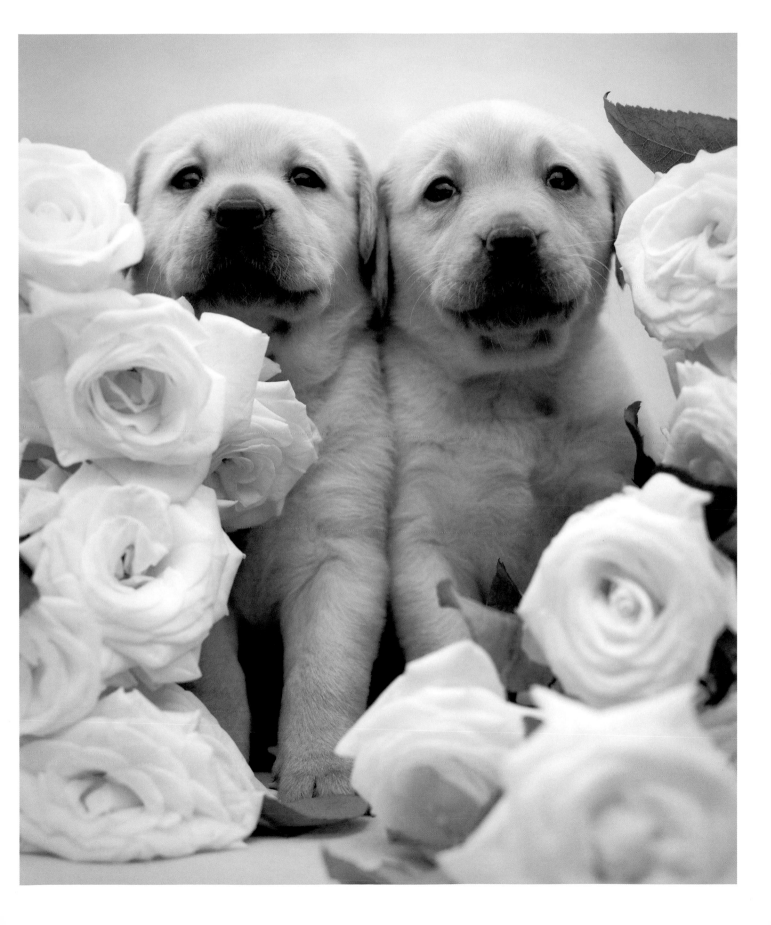

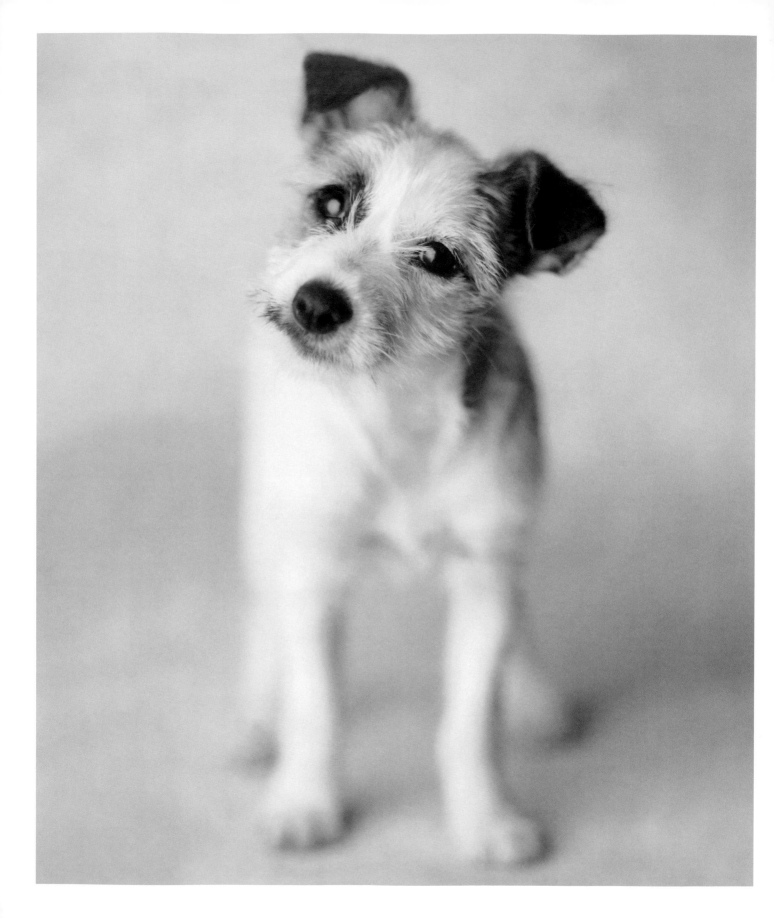

If you trip over love you can always get up.

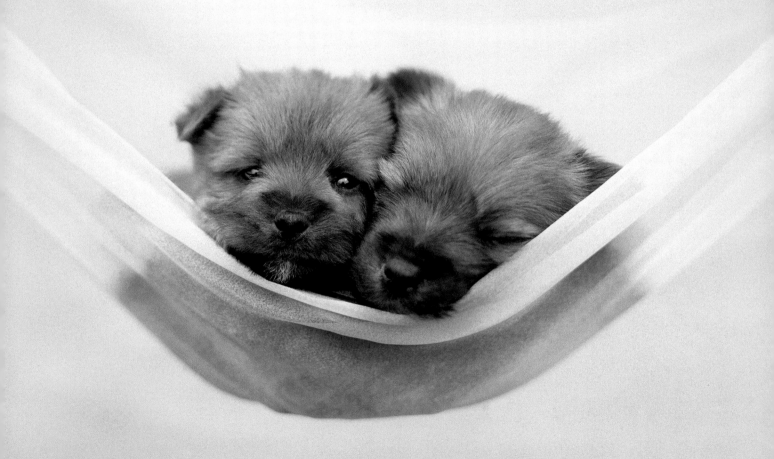

If you fall in love you fall forever.

ANONYMOUS

SCOUBIDOU GREAT DANE ▶

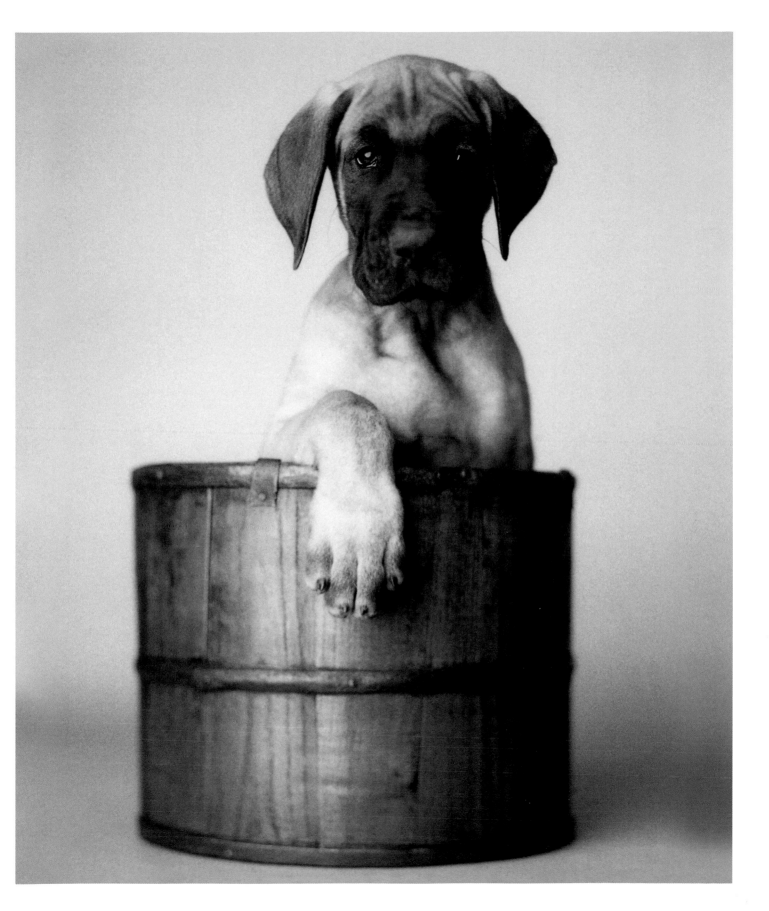

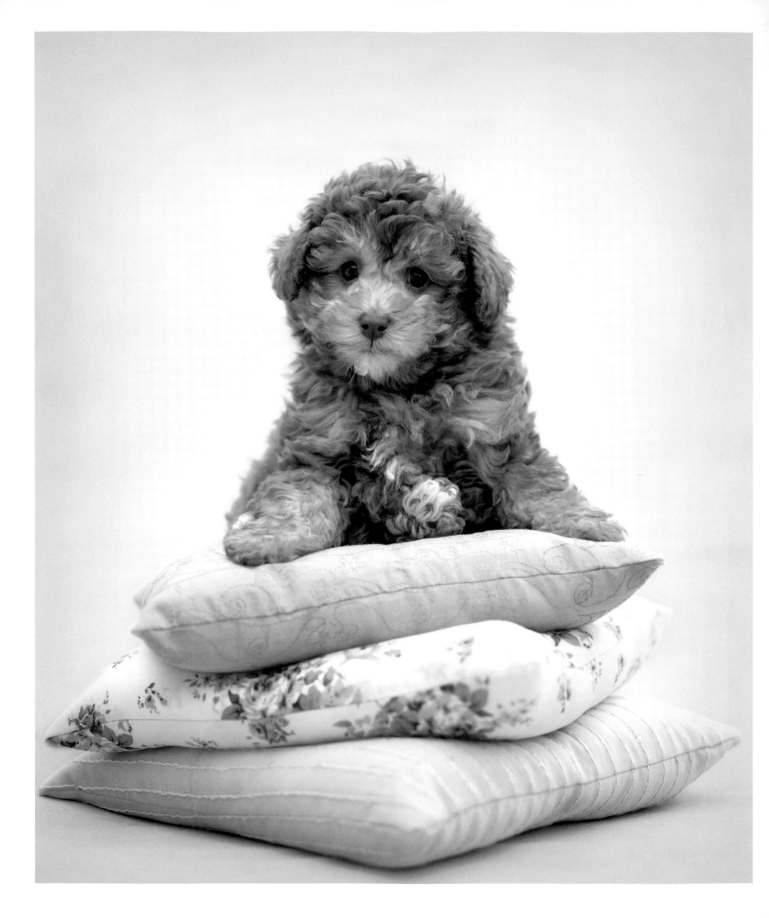

If you fall in love, make sure the landing is soft.

LULU & FRED CHIHUAHUA ▶

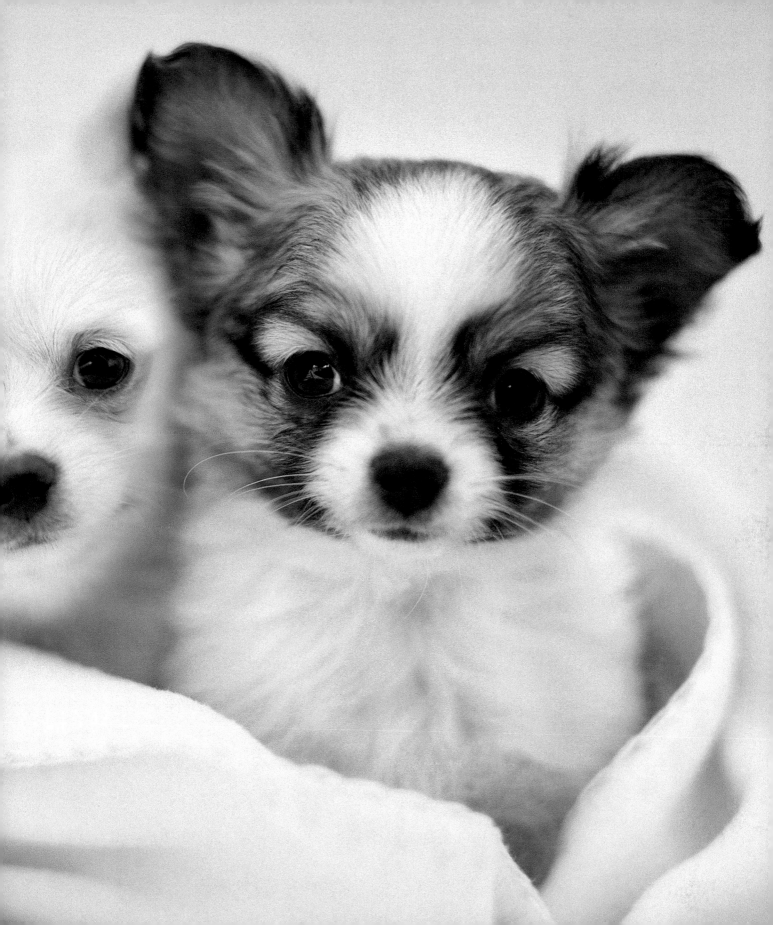

There's no escape from the love bug.

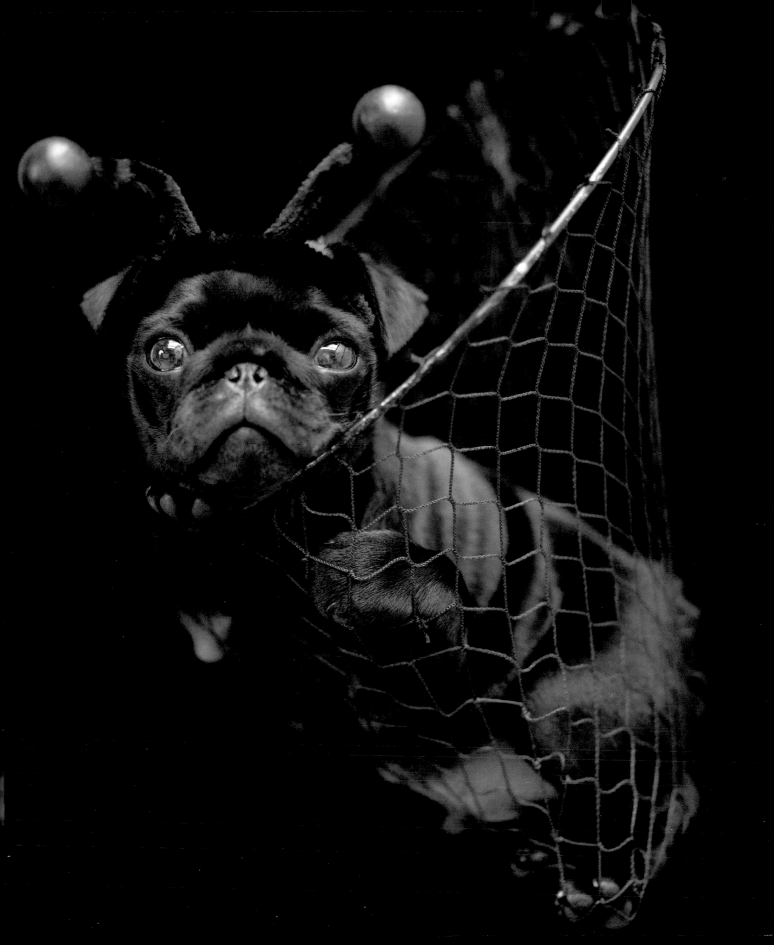

Love: two minds without a single thought.

PHILIP BARRY

HOLLY & MICKEY ENGLISH COCKER SPANIEL ▶

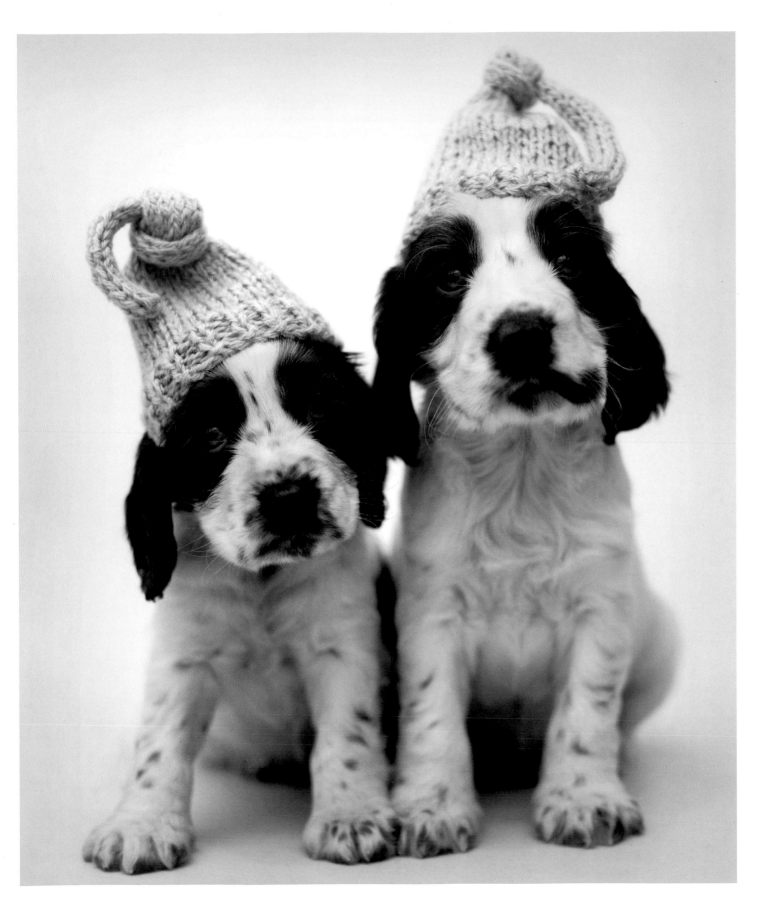

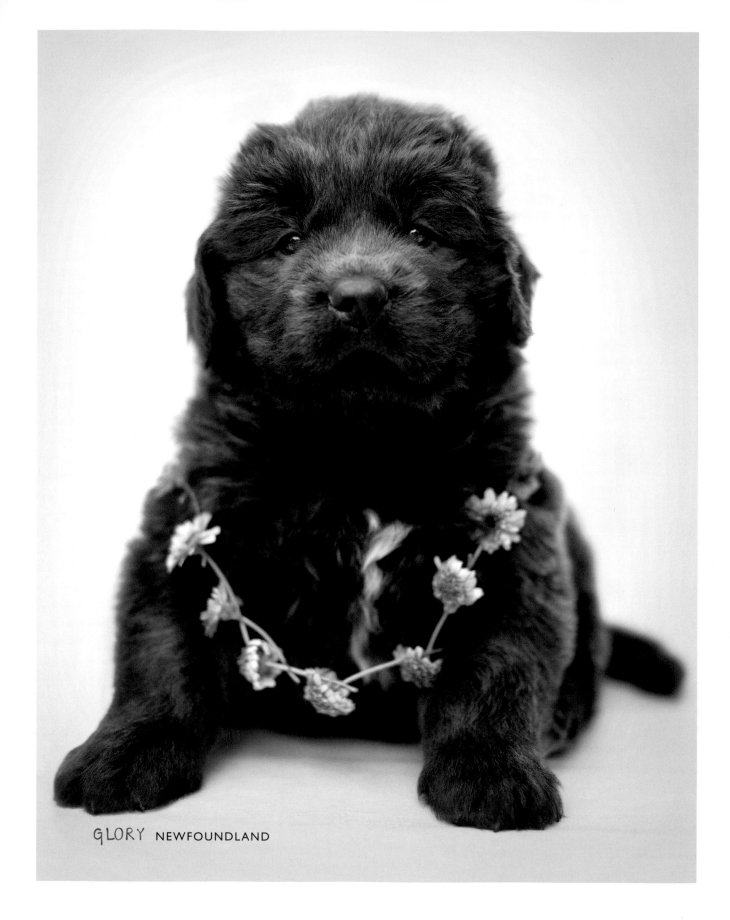

GLORY NEWFOUNDLAND

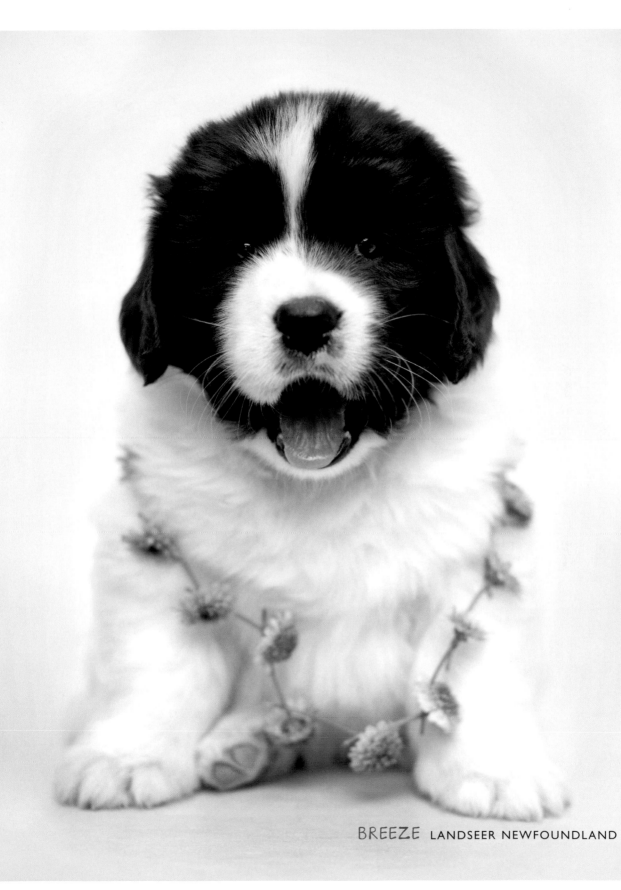

BREEZE LANDSEER NEWFOUNDLAND

First love is a little foolishness

and a lot of curiosity

GEORGE BERNARD SHAW

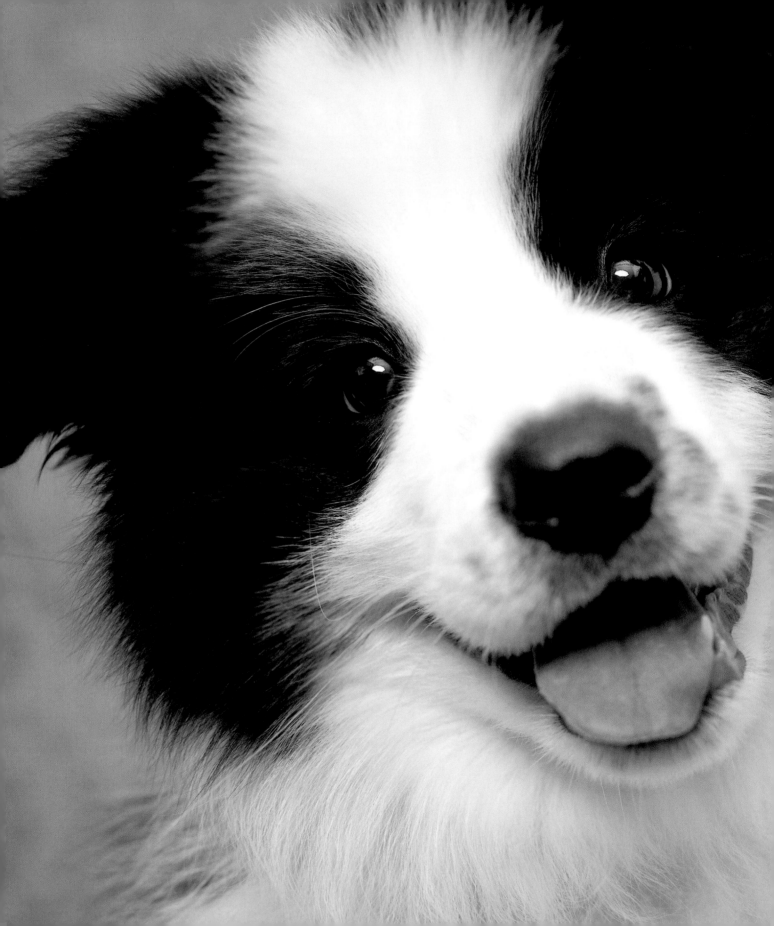

PUCK BORDER COLLIE

The course of true love never did run smooth.

WILLIAM SHAKESPEARE

ZEBA CHIHUAHUA CROSS ▶

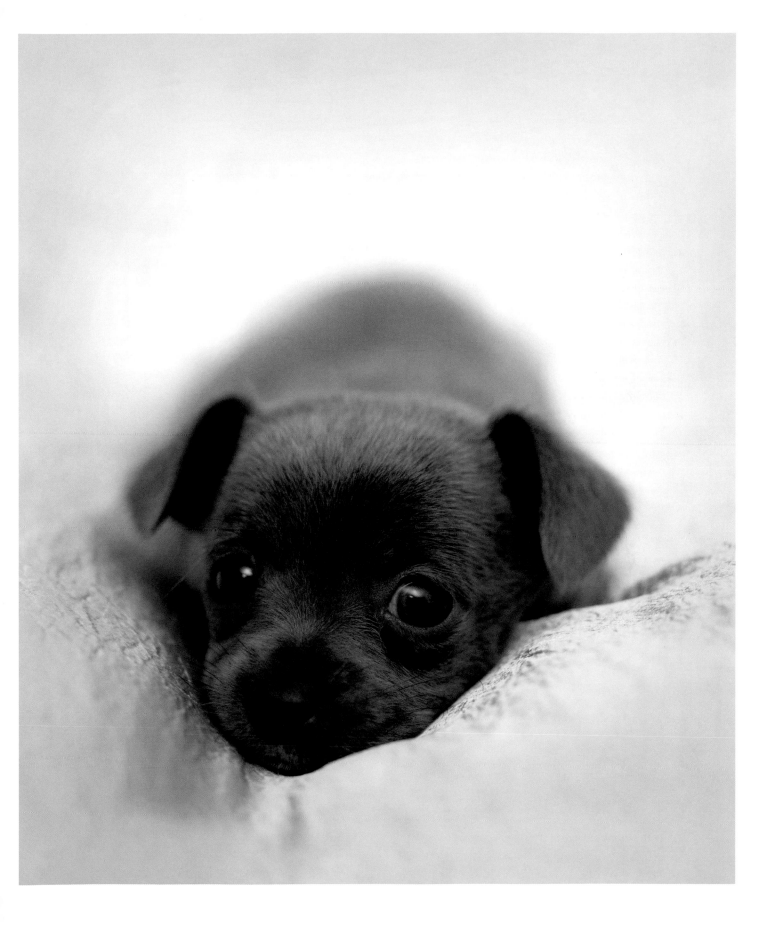

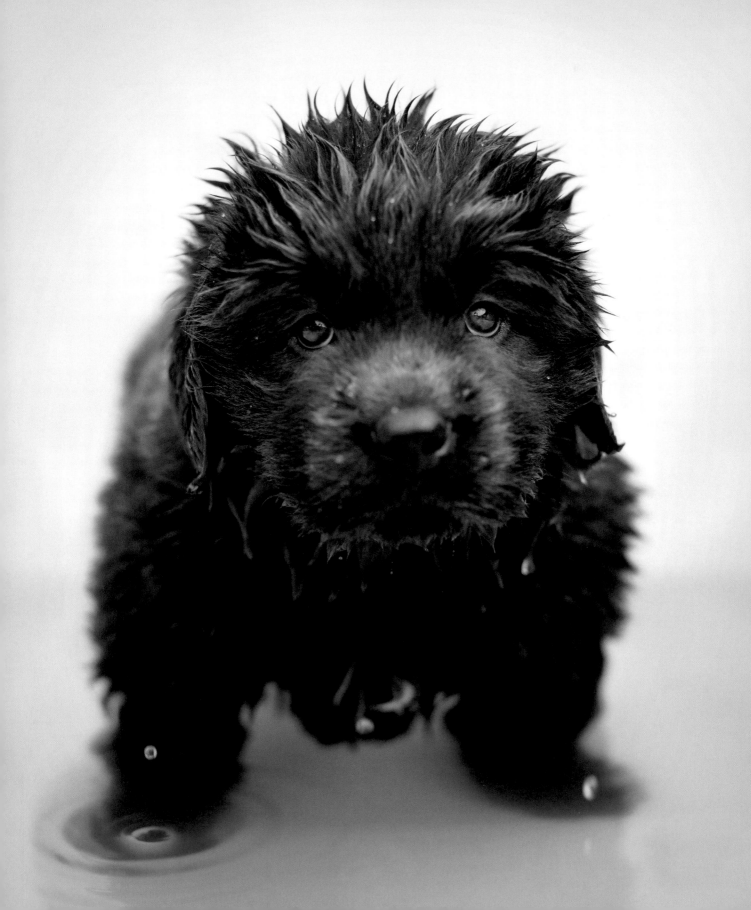

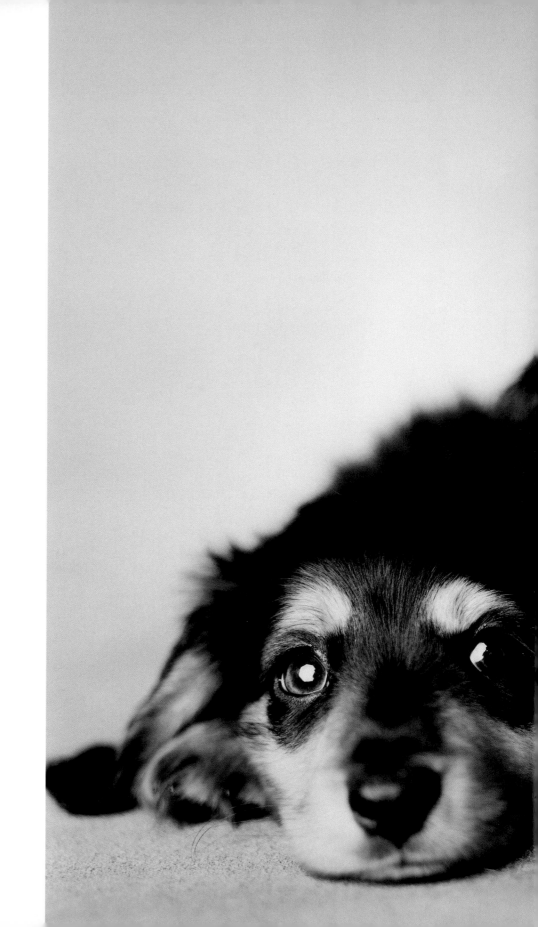

FAT JOE & TAMMY
DACHSHUND ▶

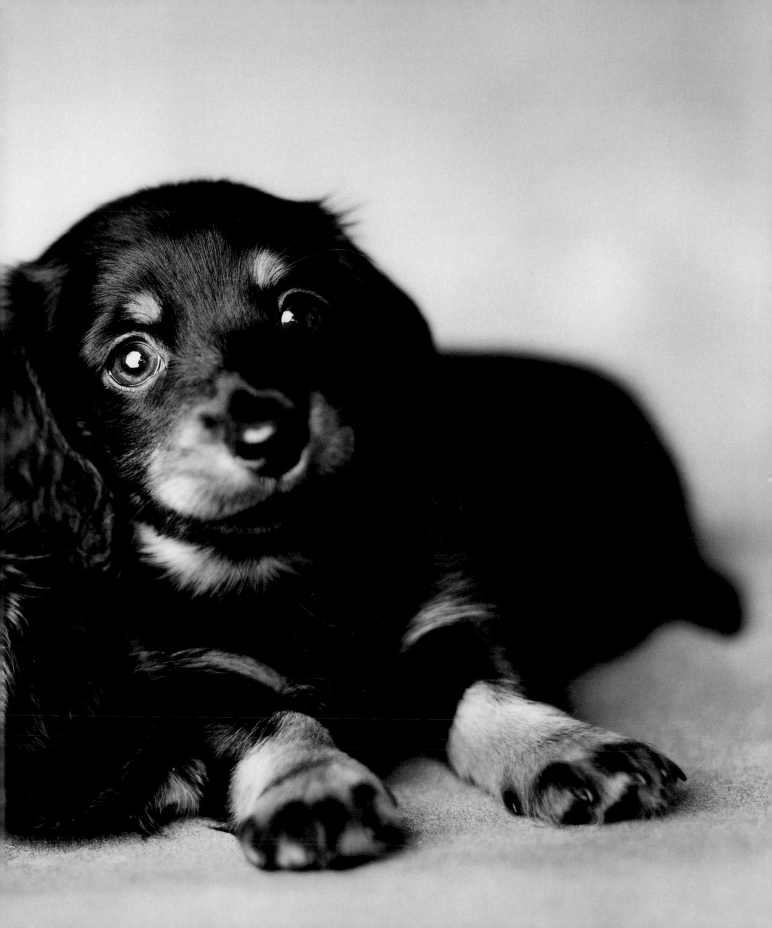

Love sees with the heart

and not with the mind.

WILLIAM SHAKESPEARE

THOMAS GERMAN SHEPHERD ▶

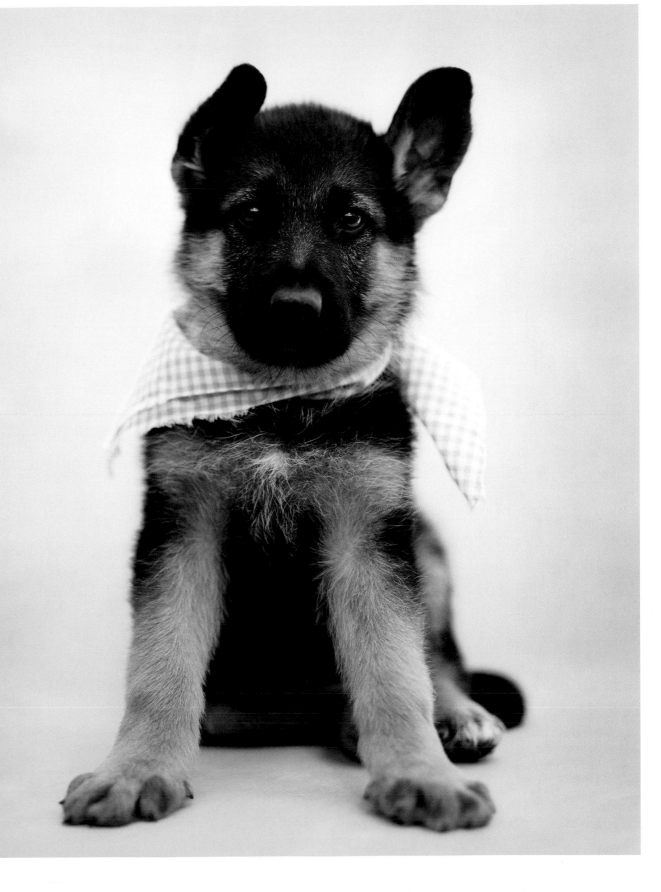

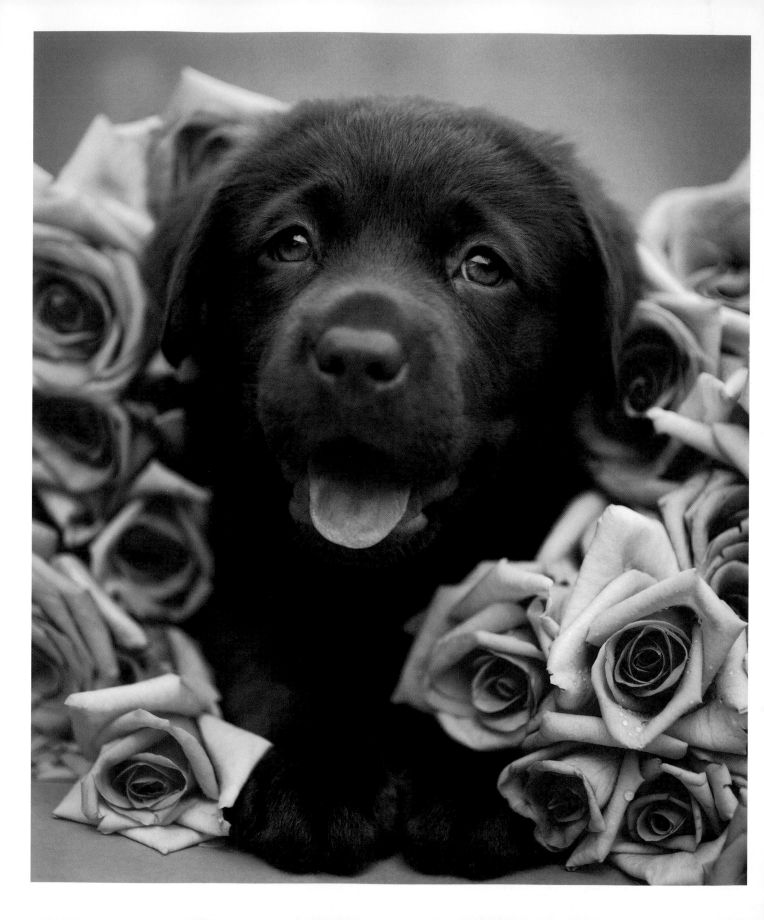

I'll still love you even when you

look like an old boot.

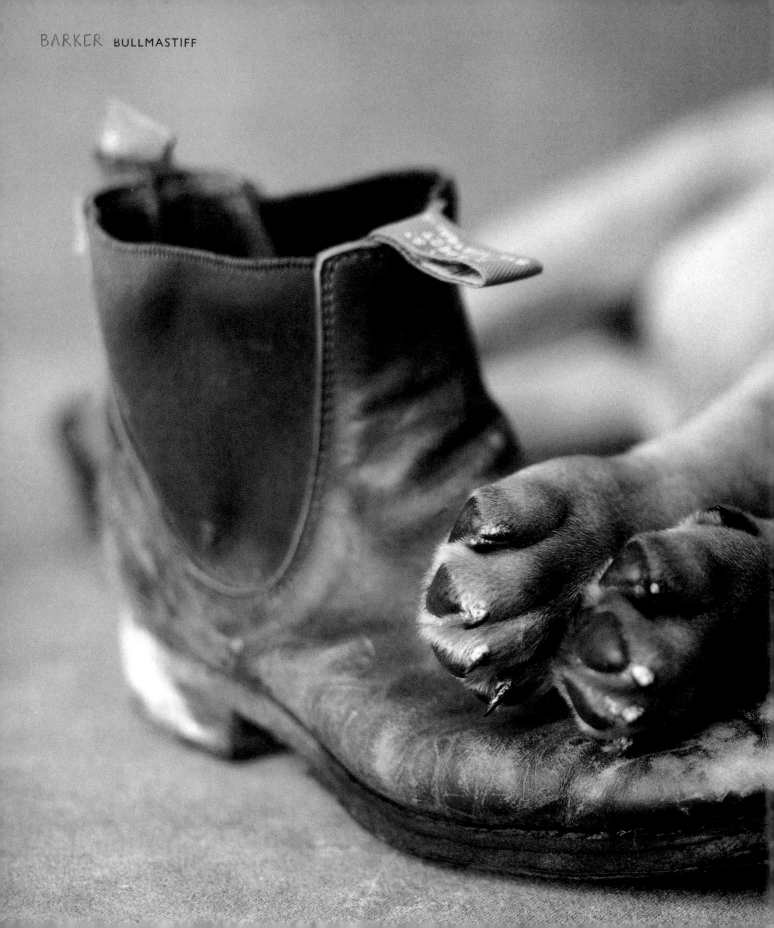

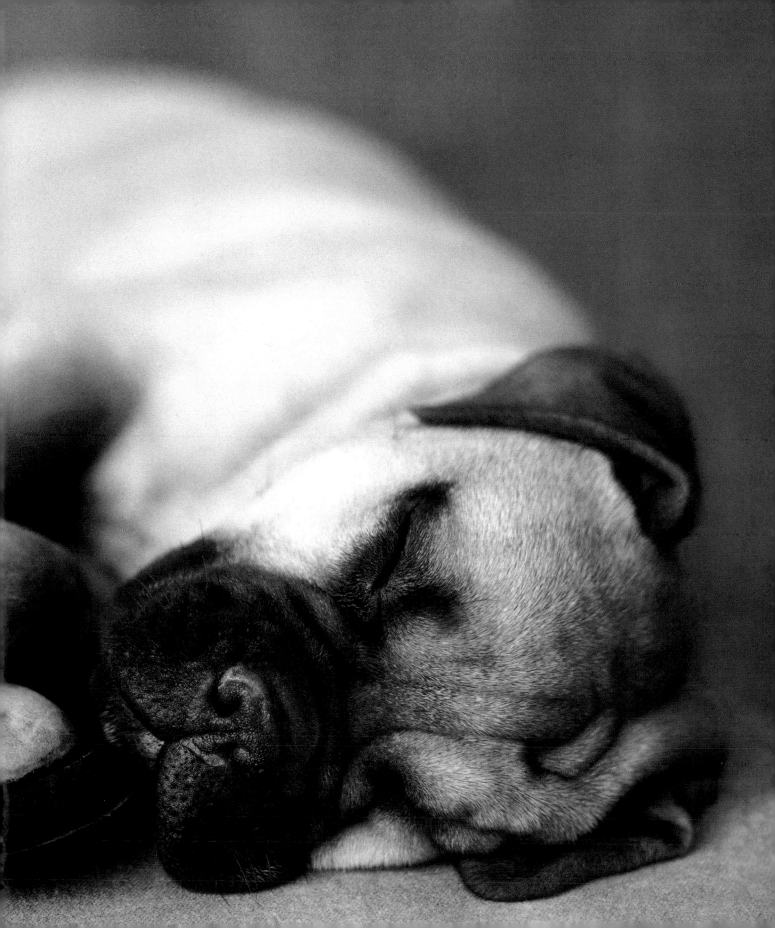

APPENDIX

Front cover and page 72
Bella – 4 months old
BICHON FRISE CROSS

When I first met Bella, I instantly fell in love with her. I was sure her legs were made of springs. She was perfectly behaved on the day of her shoot though . . . she must have left her springs at home.

Page 9
Roko – 7 weeks old
LABRADOR RETRIEVER

A cosy hat, a soft bed, and a cool breeze were the perfect combination for sending a tired puppy to sleep after an exhausting playtime with his brothers and sisters.

Page 10
Fleur – 4½ weeks old
PARSON RUSSELL TERRIER CROSS

Wearing a tiny sweater probably wasn't Fleur's favourite pastime, but she definitely knew how to pull it off with style. It wasn't long before she was prancing around the studio, head held high, showing off to the other pups in the litter.

Page 13
Kirby – 4½ weeks old
PARSON RUSSELL TERRIER CROSS

Kirby wasn't quite as confident as his sister Fleur, and once placed in his sweater he sat with a very perplexed look on his face. It could have been because, being a boy, he wasn't at all happy about wearing pink!

Page 15
Chloe – 6½ weeks old
LABRADOR RETRIEVER

Some dogs have the most forlorn expressions, even when they have the best life a dog could wish for. They certainly know how to make their owners feel guilty and give in to their every wish . . . I'm sure Chloe will be one of these dogs!

Page 16
Sebastian – 6 weeks old
ENGLISH COCKER SPANIEL

It was quite warm the day we photographed the puppies with chocolate, so poor little Sebastian had to have a second bath after he ended up with his feet, bottom, and tummy covered in Cadbury's Dairy Milk.

Pages 18–19
Zoey – 8 weeks old
BOXER

You don't often see white Boxers, but they are beautiful. Zoey was full of beans before finally tiring out and eventually becoming a ragdoll in my arms. She needed no encouragement to slumber under a soft rug.

Pages 21–22
Bruiser – 7 weeks old
BASSET HOUND

Basset Hound puppies are hilarious looking – I have no idea how they manage to get around as their ears seem longer than their legs. I'm sure it must be exhausting constantly manoeuvring around obstacles.

Page 23
Boxer – 8½ weeks old
WEIMARANER

When Weimaraner puppies are tired, they fall into a really deep sleep. So lifting Boxer off the floor and into the hammock wasn't that difficult, thanks to my assistant's incredibly gentle handling.

Pages 24–25
Rusty – 6 weeks old
BLOODHOUND

I highly recommend meeting a Bloodhound puppy, as they are sure to bring a smile to your face. Thank goodness they all had homes, or else I'm sure I would have tried to squeeze one into my bag.

Pages 26–27
Jay and Connie – 6 weeks old
GOLDEN RETRIEVER

After frantically licking honey off each other, both puppies were ready to crash. I waited for them to fall into a deep slumber and then it was easy to roll Jay gently over onto his back to create the perfect image.

Pages 28–29
Sophie – 7½ weeks old
ENGLISH COCKER SPANIEL

Sophie was exhausted after a playful morning leaping clumsily through the long grass with her littermates. So not too much effort was needed to get her to go to sleep on the pink background. She already had how to look cute all figured out.

Page 33
Romeo and Juliet – 7 weeks old
TOY POODLE

Juliet was the more confident of the two puppies and was truly the supportive sister. She sat beautifully and leaned into her brother to give him courage during his turn in front of the camera.

Page 34
Jade and Jasper – 3 months old
BICHON FRISE

You can imagine how much attention these two would receive if they were actually carried around the streets in a handbag! Luckily for them this was only a temporary stint, as the bag was a bit of a tight squeeze for two.

Page 35
Sophie and Toby – 6 weeks old
NZ HUNTAWAY CROSS

Sophie might have been the runt of the litter, but it didn't stop her from ruling the roost. She knew how to lead her playmates astray by teasing the cows and goats in the paddock next door.

Page 36
Flo – 5 weeks old
COCKERPOO

I couldn't believe how tiny Flo was when I saw her, and couldn't resist measuring just how high she was when she was sitting – a mere 7½ inches. And she wasn't even the smallest in the litter of cocker spaniel/poodle crosses, just the most angelic.

Page 38
Zion – 9 weeks old
LÖWCHEN

Zion was having a great time playing in the tissue paper, so much so that I was worried I would never be able to get him to stop and look at the camera. But I had his attention in a flash as soon as I started mooing like a cow.

Page 39
Mitsy – 5 weeks old
JAPANESE SPITZ

I have never seen puppies wag their tails so much. The whole litter's tails started as soon as I spoke to them. Mitsy's was wagging at breakneck speed. They were the sweetest little bundles of fluff and all looked exactly like miniature polar bears.

Page 41
Emma and Chester – 6 weeks old
LABRADOR RETRIEVER

All I wanted was for Chester to give Emma a lick, but he was so fond of the food we'd put on her lip that it turned into a lovebite instead.

Page 43
Horace and Puggle – 7 weeks old
BRUSSELS GRIFFON

It was such a beautiful day that I couldn't resist working outside with the puppies. It was their first experience playing in grass, and they were adorable to watch as they pounced and sniffed their way to exhaustion. Horace was so tired he promptly fell asleep, oblivious to his sister on top of him!

Page 45
Wallace – 4 weeks old
LABRADOR RETRIEVER

Talk about chocolate box. My heart melted when I saw Wallace and his littermates. They were as wide as they were long, with fat little bellies, and they waddled rather than walked.

Page 46
Gracie – 4½ weeks old
DACHSHUND CROSS

When I finished making the hat for the photograph, I was worried that I hadn't made it big enough, since it was too small for my cat when I tried it on for size. But it fit Gracie perfectly, as she was only half the size of a fully grown cat.

Pages 50–51
Dozer and Asha – 7 weeks old
LEONBERGER

The size difference of puppies within the same litter often amazes me. It was a big contrast to have the largest and the smallest of the litter at either end of the bookcase holding up the books.

Pages 54–55
Boss – 11 weeks old
DOGUE DE BORDEAUX

It was quite a sight when I drove into the property and saw eleven puppies playing on the lawn. I was glad that tug of war seemed to be a favorite pastime for Boss and his siblings. It was one of the games that I was hoping they would perform for me.

Pages 56–57
Lexie – 4½ weeks old
DACHSHUND CROSS

Lexie instantly bonded with the teddy bear I had purchased as a prop for her photography debut. As she trotted around the studio with the large bear in her mouth, she spent more time tripping over it than moving forward.

Page 59
Elly – 6 weeks old
BLOODHOUND

I photographed Turbo, Elly's dad, when he was a pup and had a hard time keeping him still. So, you can imagine my surprise and joy when Elly not only sat still but also kept her paw placed perfectly on top of the ball.

Page 61
Coco and Shilo – 11 weeks old
DOGUE DE BORDEAUX

It always amazes me that a litter of eleven puppies of the same breed can all be so different in looks and personality – these two even cocked their heads in opposite directions when I made a noise like a monkey.

Page 62
Maxi and Baxter – 7 weeks old
AUSTRALIAN CATTLE DOG

Baxter was another pup I could easily have taken home. Maxi was gorgeous too, but a lot of personality shone from Baxter. It wasn't an easy mission keeping them both inside the toy wagon. As soon as I made a noise to attract their attention, they made an attempt to escape. Thank goodness for assistants with fast reactions!

Pages 66–77
Ruby, Hotai and Milly – 8 weeks old
BOSTON TERRIER

They say two's company and three's a crowd but, when it comes to puppies, the more the merrier. Although Ruby looks left out in this image, she was only frustrated because she wanted to go to sleep.

Page 68
Connie and Jay – 6 weeks old
GOLDEN RETRIEVER

Being smothered with honey could easily have turned into a sticky mess, but Connie and Jay loved the taste of their new treat so much that they licked each other clean and no baths were required after the shoot.

Page 71
Charlie – 7 weeks old
WEST HIGHLAND WHITE TERRIER

At first Charlie wasn't sure why he was being encouraged to sit face first against a clear Plexiglas wall. However, as soon as he realized that it had been smeared with dog food, there was no stopping that tongue, and soon the Plexiglas was spotless.

Page 74
Randy – 8½ weeks old
WEIMARANER

Randy was lanky and big eared, totally adorable but also very active and mischievous. Luckily, the years I have spent perfecting animal noises behind the camera managed to stop Randy for a split second – just long enough for me to capture his intrigued look.

Page 75
Minkee – 3 months old
AFFENPINSCHER

Full of mischief and life, the only way to keep little Minkee in one place was to put her in a box. She certainly proved she knew how to pose once she was contained.

Page 77
Turbo – 10 weeks old
BLOODHOUND

I have never met such a sweet-natured, yet mischievous and naughty puppy! My assistant and I worked for what seemed like hours trying to persuade him to sit still for the camera, but all he could do was wriggle around and throw tantrums. I finally managed to capture the "one-shot wonder."

Pages 80–81
Rebel and Grumpy – 6 weeks old
ENGLISH BULLDOG

These little Bulldogs were just like fat cherubs. They thought it was a great game to play in a paper bag. You can see how Grumpy got his name by the expression on his face, even though he was anything but grumpy.

Page 83
Tucker and Milly – 8 weeks old
CAIRN TERRIER

I can remember thinking that these puppies looked just like baby rhinos when they were running around the studio. They were so rotund, with short legs – the perfect shape to pose as little lifesavers.

Page 84
Moses and Max – 8 weeks old
SCHNAUZER CROSS

There are some gorgeous "designer" dogs being bred now and the Schnauzer/Jack Russell cross, more commonly known as Schnacks, has got to be one of my favorites. These two were so different – all Moses wanted to do was tear around the studio, whereas Max was more interested in having a cuddle.

Page 87
Dali – 8 weeks old
BRUSSELS GRIFFON

Griffons' expressions always seem so sad, although I can vouch for the fact that they are an extremely happy, playful, and lovely natured breed. Even though Dali looks sad and lonely in this image, he really wasn't.

Pages 90–91
Cody and Carter – 7 weeks old
WEST HIGHLAND WHITE TERRIER

This is another breed that is as wide as it is long when young. All the puppies were leaping as high as their short little legs could take them when we first arrived, each trying to get our attention to be the chosen one.

Page 93
Boxer, Randy and Black – 8½ weeks old
WEIMARANER

Weimaraner puppies only have two speeds … full speed and asleep! They proved too difficult to photograph together while awake so sleeping was the only way. When they all collapsed in a heap, we had the perfect opportunity to rearrange them into a more stylized jumble.

Pages 94–95
Moose – 4 weeks old
LABRADOR RETRIEVER

Moose looked totally adorable when my assistant dressed him in his sweater, but he found it quite difficult to walk around. I was grateful that he was exhausted from too much playtime – sleeping in a cuddly sweater was much more his style.

Page 97
Fleur – 4½ weeks old
PARSON RUSSELL TERRIER CROSS

Fleur was such the little poser, all I had to do was place her in position and make a noise behind the camera to get her attention. Within minutes the image was captured. I love models like Fleur.

Page 98
Ziggy – 14 weeks old
AFFENPINSCHER

With his paws tucked under him, Ziggy looked like a ball of fluff. He wanted to go to sleep and I had to encourage him to stay awake long enough to take a few photos. When his eyes were shut I found it extremely difficult to focus the camera.

Page 99
Tina – 9 weeks old
STAFFORDSHIRE BULL TERRIER CROSS

This little puppy has landed on her feet – she has been adopted by a wonderful family and now lives on a farm with plenty of playmates. She was fighting to keep her eyes open while having her photograph taken after spending the morning running in the paddocks.

Page 100
Bart – 4½ weeks old
PARSON RUSSELL TERRIER CROSS

It was the sweetest thing photographing Bart. He was so tired from playing with his littermates that he kept nodding off while posing. He tried so hard to sit up and watch the action but exhaustion got the better of him and it wasn't long before his nose hit the floor.

Page 103
Smoke – 6 weeks old
BLOODHOUND

Smoke wasn't impressed with having to sit in a suitcase. He would much rather have been running around with the other Bloodhound pups. His frustration led to the perfect expression for me though – and I promise he wasn't in there for long!

Pages 106–107
Lizzie and Piper – 3 months old
BEARDED COLLIE

I had taken a fan with me to the shoot to create the look I wanted, but when we arrived at the farm to photograph the puppies it was so windy outside that I decided to make use of the natural elements. The effect was much more dramatic and the puppies loved it.

Pages 108–109
Eeney, Meeny, Miney and Mo – 7 weeks old
STAFFORDSHIRE BULL TERRIER CROSS

My assistants thought I was crazy when I told them I intended to get four puppies to sit together on a skateboard. "Have faith," I told them and, sure enough, it wasn't that long before the pups worked out their positioning and I was able to capture them going for a stationary ride.

Page 110
Ernie – 8 weeks old
TIBETAN TERRIER

I had a choice of two puppies for this shot – one who was determined to pull the curtains down and destroy the set and the other who was so shy he kept on backing up and hiding behind the curtain. It was Ernie, the shy one, who we finally managed to win over.

Page 112
Baxter – 4½ weeks old
NEWFOUNDLAND

It is impossible not to fall in love with these puppies. They are the friendliest, fluffiest, and clumsiest around. It's amazing to think that by the age of six months they can easily reach 110 lbs and still be growing. They are known as the Gentle Giants, and every moment you spend with them you are reminded why.

Page 113
Pippi – 8 weeks old
BICHON FRISE CROSS

I was actually photographing kittens the day I captured Pippi on film. She was a new member of the Maine Coon breeder's household and was far too irresistible for me to pass up a photographic opportunity.

Page 115
Oscar and Maysie – 5½ weeks old
LABRADOR RETRIEVER

Once I finally managed to drag them away from chewing the roses, Oscar and Maysie posed like true professionals. But it wasn't long before they were back to causing chaos.

Page 116
Becky – 3 months old
PARSON RUSSELL TERRIER

Becky was a typical cheeky, mischievous puppy owned by my niece. I was always hearing new stories about how Becky was causing chaos and ruling the household – including the older and larger dog!

Page 118
Tilly and George – 4 weeks old
AUSTRALIAN TERRIER

The breeder told me that I would need to photograph the Australian Terriers at a younger age than other breeds or I would struggle to get them to sit still. How right she was. When I saw the puppies two weeks later there was no stopping them!

Page 121
Scoubidou – 9 weeks old
GREAT DANE

Eleven Great Dane puppies had a turn in the wooden barrel . . . it was the only way I was able to keep them still and stop them from wrestling and pouncing on each other.

Page 122
Juliet – 7 weeks old
TOY POODLE

Juliet was one of the cutest puppies I have ever met – she was like a wind-up toy. Once I had prised her away from harassing her siblings and placed her on top of the cushions, she was quite bewildered and stopped moving long enough for me to capture the image.

Pages 124–125
Lulu and Fred – 7 weeks old
CHIHUAHUA

Chihuahuas are small at the best of times, but Chihuahua pups are tiny – they easily fit into your hand. Being so small, Lulu and Fred felt a lot more confident having each other to lean on for support during their photo shoot.

Pages 127
Simon – 9 weeks old
PUG

When I first met Simon I immediately thought he looked like a little bug. My assistant came up with the great idea of photographing him as a "lovebug" and Simon happily obliged posing perfectly in the net.

Page 129
Holly and Mickey – 6 weeks old
ENGLISH COCKER SPANIEL

These tiny hats were originally knitted for kittens, but I haven't ever managed to find any kittens willing to wear them! Holly and Mickey had no objections, although Mickey's was slightly small and kept popping off.

Page 130
Glory – 4½ weeks old
NEWFOUNDLAND

This was the first time I had ever seen a grey Newfoundland and I fell in love instantly. She was so perfectly behaved and utterly beautiful.

Page 131
Breeze – 4½ weeks old
LANDSEER NEW FOUNDLAND

This little Landseer was the "chosen one," the pick of the litter, and destined for a life of fame. What better way to

start life than by posing for a portrait and becoming world famous at the age of 4½ weeks?

This little guy was perfectly suited to be named after the character with a split personality in *A Midsummer Night's Dream*. He could be adorable and sweet one minute and then, as his owners would say, the son of Satan the next. I just think he is too smart and handsome for his own good!

Often I find that just capturing the expression of an animal is enough for an image to work. In Zeba's case this was true – it would be hard for anyone's heart not to melt once those eyes looked at you.

Nothing is more appropriate for a puppy from the breeding stock of Watermark Newfoundlands than to be photographed dripping wet. Although at a mere 4½ weeks of age, this pup wasn't at all impressed.

I originally wanted to try to photograph two Dachshund puppies sitting back to back, but all Fat Joe wanted to do was lie down. Tammy was perfectly happy to use him as a cushion.

I've always loved the way German Shepherd pups' ears flop when they are little, although one of Thomas's had started to straighten just days before the photo shoot, unlike his brothers', which were still crossing over.

Dozer is one of this breeder's many adorable and perfectly behaved puppies. They are all so relaxed, have superb temperaments, and always have smiling faces.

After running around a farm with his eight littermates, Barker was quite happy to sleep anywhere, even if it was next to an old smelly boot.

There was so much fur on Maddox that I doubted he would fit inside the box I had made for him. But I actually had to prop him up slightly once he was inside, as underneath all that fur he was a lot smaller than I realized.

ACKNOWLEDGMENTS

I jumped at the opportunity to create a book concentrating purely on puppies. I have to admit, as much as I love all animals, dogs hold a very special place in my heart. Puppies are endlessly entertaining. I have enjoyed so many humorous moments while creating the images for *Snog* – and many frustrating ones, too, as puppies often have minds of their own! Although who can complain about spending endless hours playing with puppies? I do have the best job in the world.

It would not have been possible to complete a collection of images such as this without the help of numerous people. Charlotte Anderson, my faithful assistant, has been a true asset, helping me create the images for *Snog*. Thank you, Charlotte, for your endless patience and the many long-suffering moments having to clean up countless little "messes." To my wonderful friend Rae Jarvis, a huge thank you for always being there for me, lending a hand with the photo shoots, finding props, and for your magnificent knitting and sewing abilities. I couldn't do this without you.

An enormous thank you, yet again, to Geoff Blackwell, Ruth-Anna Hobday, and the entire team at PQ Blackwell for making this book possible.

Many thanks to the team at Rachael Hale Photography Ltd., especially Robine Harris, whose enthusiasm for my imagery and wonderful retouching skills add the final piece of magic that makes my imagery jump off the page.

A HUGE thank you to all the puppies and their owners and breeders for so generously allowing me to work with their precious, yet often boisterous, four-legged babies. *Snog* would not have been possible without your enthusiasm or cooperation.

Many thanks again to Bob Kerridge and the amazing team at the Auckland SPCA. The support and trust placed in me means more to me than words can express. Thank you so much to the foster parents who allowed me into their homes to work with the pups that were in their care. You truly are the most generous and caring people to open your homes and hearts to young dogs in need. The crossbreeds we often so rightly name as SPCA Specials are just as beautiful and deserving of wonderful family homes as the pure breeds. A dog is a dog, they are all as loving and wonderful as each other, and if you treat them with respect you won't find a more loyal companion.

Thanks to Image Centre (scanning/retouching), PCL (color printing and processing), Labtec (color and black and white printing), and Apix Photographic Supplies for the work and support in the creation of my imagery.

Thank you to David Ford for his title inspiration.

To Brent and Gina-Maria Franich, close friends who have offered a tremendous amount of encouragement, advice and guidance … an abundance of thank yous!

A final thanks to my family and friends – my parents, Bob and Barbara, my twin sister, Rebecca, and my closest friends, Rae, Jo, and Kirstin. Kirst, I can't thank you enough for finding me Kizzie, my newly adopted companion. She is a remarkable dog and has already brought so many more smiles to my face.

Those who own a dog know the joy and magic they bring to our lives. A puppy is the perfect way to start your friendship, and I hope you enjoy some of that puppy magic in *Snog*.

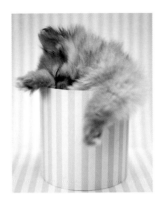

Little, Brown and Company
Hachette Book Group USA
237 Park Avenue, New York, NY 10017
Visit our Web site at www.HachetteBookGroupUSA.com

First North American Edition: October 2007
Published by arrangement with PQ Blackwell Limited

ISBN 978-0-316-00295-0 / 0-316-00295-X
LCCN 2007927144

Printed in China